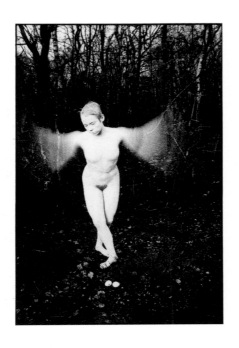

APPROACHING
PHOTOGRAPHY

PAUL HILL

APPROACHING PHOTOGRAPHY

PAUL HILL

photographers'
pip
institute press

For Angela

Second edition published 2004 by

Photographers' Institute Press

an imprint of The Guild of Master Craftsman Publications,

166 High Street, Lewes,

East Sussex BN7 1XU

First edition published 1982 by Focal Press

ISBN 1 86108 323 8

A catalogue record of this book is available from the British Library.

Publisher: Paul Richardson

Art Director: Ian Smith

Production Manager: Stuart Poole

Managing Editor: Gerrie Purcell

Editor: James Evans

Art Editor: Gilda Pacitti

Typefaces: Helvetica and Palatino

Colour origination: Icon Reproduction

Printed and bound by: Stamford Press Limited, Singapore

PREFACE

This book emerged from a meeting of photography teachers called by a well-known publisher of photography books over two decades ago. I was one of those teachers and we decided that students embarking on their photographic education needed an illustrated guide that focused more on the concepts behind photographs rather than the techniques used to make them.

There was no shortage in those days of publications concerned with applications and techniques, but little or nothing on the 'language' of photography despite the interesting developments taking place in that period. For example, degrees were being offered by colleges of higher education for the first time ever, fine-art galleries had begun to show exhibitions of photographic prints, visual-art commissions were being awarded for photography projects, workshops had become popular events for those professional and amateur practitioners seeking to learn from the 'masters' of photography, television programmes about the medium were broadcast fairly regularly, and photography and photographers featured in an increasing number of newspaper and magazine articles. Because I had an involvement with some of these new initiatives – as a photographer, writer and teacher – the publisher asked me to write what became the first edition of *Approaching Photography*.

Although much has changed in the interim – and this is reflected upon in detail elsewhere in this second edition of the book – it is surprising how much has stayed the same. The majority of photographers still want to pursue similar creative pathways that concentrate on personal expression, good craftsmanship, conceptual rigour, and social and cultural commentary, as well as improving their own image making and locating their position within the practice of contemporary photography.

I would like to thank all those who have contributed to this book; in particular: the photographers who have so generously allowed me to use their work; Roger Taylor for his foreword and his invaluable comments on the text; the late Aaron Scharf for the foreword to the first edition; Jack Taylor who first commissioned me to write the book; Iona Cruickshank, De Montfort University, Leicester, and Dewi Lewis who arranged invaluable practical assistance that made this edition possible; Brian Randle, Bill Jay, John Mulvany and, particularly, Thomas Cooper from whom I learned so much about photography; my wife, Angela, a photographer who has supported me over the years in more ways than she could possibly realize (and typed the original manuscript too!); my family for being photographic subjects and helpers on many occasions; my students and colleagues at the various workshops, colleges and universities where I have taught since 1970; and the editorial staff of PIP who have helped me hone this second edition and shown great enthusiasm for the project.

PAUL HILL
Bradbourne, Derbyshire, UK

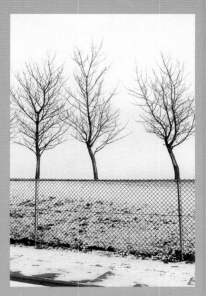

CONTENTS

FOREWORD

This book was first published in 1982, at a time when photography stood in a very different relationship to society than it does today. This was the decade that marked the emergence of a new concept that was to change the way in which we made images forever. The very idea of digital imaging seemed impossible and well beyond the reach of mainstream photography. As it was both expensive and inaccessible to the majority of individuals, the notion of taking and making photographs at home on a computer seemed impossible. But 20 years later the digital revolution is upon us all. Once computers became an essential part of home education and school life their numbers increased dramatically and the sophisticated way in which they handle image files made it possible for the complexities of photography to belong to the individual again. Computers are the darkrooms of the twenty first century.

But digital imaging is something very different to conventional photography. Despite the obvious parallels of lens, camera, viewfinder and shutter release, the way in which the image is recorded, processed and stored is fundamentally different. The most significant difference lies in the extraordinary facilities available for manipulating and altering digital files, achieving results that even the most sophisticated photographer could never have aspired to 20 years ago. And here is the great divide – between today's digital imaging and the photographic world which Hill addressed in 1982, when setting the controls of most cameras still relied on skill and judgement rather than the preconceptions of a manufacturer hell-bent on automating everything.

In truth, this book is less about the distinction between silver and pixels, and everything to do with the thought processes that impel photographers to engage with the real world, whether in landscape or social documentary mode, and ask why they chose particular styles and methods to reflect their feelings and ideas. Even though photography has never been easier and cheaper, fundamental questions about the nature of photographs still remain. Why do we make photographs at all, and what is it beyond the lure of the equipment that engages our attention? Once technical success is guaranteed, and manufacturers ensure that it is, photographers soon realize that taking photographs for their own sake has little meaning. It's a little like perfecting the technique for dovetail joints but not knowing what it is you want to make. There has to be some purpose to it all.

For most of his professional life, Hill has been a photographer and educator in equal measure. In 1976, with his wife Angela, he founded 'The Photographer's Place' – the first independent photographic workshop to be established in the UK whose ethos was to raise awareness of the power and potential of photography as a medium of personal expression. In those days there was nothing quite like it and the word quickly spread among that frustrated band of individuals for

whom photography had never quite matched up to their expectations. What they needed was a guiding hand, a gentle shove in the right direction and, above all, the encouragement to help them succeed. This ethos is enshrined in his book and still holds as good today as it did in 1982.

There are some significant differences though. Way back then, black & white film, papers and darkrooms for processing and printing were part of the photographic scene. Few cameras automatically controlled the focus or exposure. It was expected that you knew about ISO film speeds, the relationship between aperture and shutter speed and their effect upon the final outcome. The idea that you practised with your camera like a pianist on a silent keyboard until finger perfect would not have seemed out of place. It was expected that to be a good photographer one had to have complete mastery over the materials and equipment before one could move ahead and consider the content. Struggling to overcome mistakes was an unhelpful diversion. This approach still holds good today, for what we are dealing with here is the craft of photography, the underlying principles that govern the way in which the camera sees and records what lies before it. Those of you brave enough to use black & white film and manual cameras should be applauded for your courage in returning to the fundamentals of photography. But don't be disheartened if this is not an option for you; this book addresses the basic issues that lie beyond mere technique and materials. Whatever your photographic circumstance and ambition, take heart from what Hill has to tell you; there is something here for you. In the 20 or so years since its first publication this book has become something of a classic text, one that is essentially different to other 'how-to-do-it' manuals.

In the foreword to the first edition, the eminent art historian and champion of photographic history Aaron Scharf concluded with this sentence:

> 'This book seems to me a photographer's testament, a synthesis of mind and eye in its penetrating explorations of the seeing machine when put in human hands.'

There could be no better testament than this.

ROGER TAYLOR
Senior Research Fellow in Photography,
De Montfort University, Leicester, UK

INTRODUCTION

Photography is not about focal lengths, film speeds and f-stops, it is about images: what you point your camera at, what you include within its viewfinder, what image you make into a print, and what context you place that photograph in. This book attempts to explain and illustrate what photographs are, how they were used in the past and, more particularly, how they are used in the present day.

The Eastman Kodak Company used to have an advertising slogan, 'You press the button, we do the rest', thereby encouraging among its customers a somewhat unthinking approach to photography. The handheld camera and the rolled film revolutionized the medium in the late nineteenth century, making photography available to the masses. If Kodak did the processing, the 'photographer' didn't have to know anything about that either. You were given the illusion of being a photographer – an auteur – by just pressing the button. Power without responsibility. And yet, simpler and more efficient cameras and improved materials and imaging technologies can free the photographer to consider and investigate what is produced, rather than how it is produced.

Attempts to evaluate a photograph critically can be complicated and frequently inconclusive, and photographers rarely undertake a personal and serious examination of photographic imagery and the medium in general. Most camera owners rely on the possession of easily valued equipment for their reputation as photographers, rather than making difficult judgements on their ability to produce pictures.

The power of the medium to inform and reveal, whether publicly or privately, cannot be overestimated. But is our knowledge of the functional, let alone the artistic, use of photography good enough? Most of us see scores of photographs each day, but do we bother to look at even one to try to find out what it 'says'? The intense critical scrutiny and the frequent rigorous debates that take place in the other arts must surely be worthy of emulation by photographers. The dismissive

' Most camera owners rely on the possession of easily valued equipment for their reputation as photographers, rather than making difficult judgements on their ability to produce pictures.'

attitude many people have towards photography comes through ignorance, rather than prejudice. This is understandable if you consider that there are not many specific histories of photography and that photography rarely features in general history books as a subject in its own right. And yet photography is an essential part of modern life: tens of thousands of manufacturers and service industries throughout the world use or are dependent on it, so the effect it has on our civilization is enormous. In 2003, every European made 16 photographs from film, and 23 by digital means, per month. Worldwide, 85 billion photographs were made from film in 2004!

Most photographs are made by amateurs, but even untutored hobbyists can be serious photographers, assiduously reflecting their lives and culture – perhaps more powerfully than most professionals. There is something very democratic about photography: everyone can make a photographic image, everything can be reduced or enlarged to the same size, and everything photographed in black & white becomes part of the same monochromatic scale. But perhaps its lack of mystique obscures its inherent qualities for most people, and its potential as a vehicle for expression is rarely realized because of its simplicity. We use a camera, but do we really understand what photography is? We look at photographs, but do we really know what they mean?

Throughout most of the history of photography there seems to have been two main camps: one that exploits the medium's verisimilitude (the largest camp), and another that believes a photograph can transcend the information it contains. One is no better than the other – both need the technical ability to produce the picture wanted, and both introduce other difficulties – they are just

' Although it is very helpful – for a serious study of the medium – to be conversant with various photographic genres, "schools" and movements, you should aim to end up controlling your own destiny.'

motivated by different attitudes and approaches. The more you find out about photography, the more you realize that the photographer has to grapple with philosophical, ethical and moral questions, as well as with technical problems. Some of these questions are debated in this book.

Photography suffers from the fact that its multifarious facets can be neatly categorized. This is usually done by way of subject (i.e. the objects in front of the camera). What is more relevant – and one hopes more illuminating – is the approach taken to the subject matter, both visually and intellectually. As a photographer you have to point your camera at things that actually exist. You therefore have a marvellous opportunity to interpret the world for yourself rather than represent the ideas and prejudices of others.

Other people's methods and ideas will inevitably influence you, but eventually a personal mode of expression and communication will emerge. The sheer ubiquity of the medium should not put you off trying to come to grips with it in your own individual way. Although it is very helpful – for a serious study of the medium – to be conversant with various photographic genres, 'schools' and movements, you should aim to end up controlling your own destiny.

This book is for those who wish to take their photography seriously and beyond the 'point-and-shoot' stage. For convenience it tackles two areas. The earlier chapters concentrate on the basic aspects of photographic image making and practice: how to express yourself and communicate through photography, and how and where photography is used in the world today. Later chapters deal mostly with the different attitudes found in contemporary photography concerning the photographer as an observer of events and people, celebrant of nature and manmade objects, psychological chronicler, fine artist, conceptualist and polemicist.

The enemy of photography is the convention,
the fixed rules of 'how to do'. The salvation of
photography comes from the experiment.

Lazlo Maholy-Nagy
Photographic artist and teacher

The whole subject of photography is treated questioningly, rather than definitively. No book on such a topic can give definite answers; it can just pose the questions. You, the reader, must seek your own solutions.

The photographs used in this book have been selected to complement the various areas covered in the text. Although they function as illustrations, they should not be thought of as being subservient to the words. As photographs can and do work on more than one level of communication, there is the

' It is impossible to prove anything conclusively in photography, other than a photograph is an image made as the result of light reacting with light-sensitive material.'

obvious chance that you may read something completely different into many of the illustrations. Good! It is impossible to prove anything conclusively in photography, other than a photograph is an image made as the result of light reacting with light-sensitive material.

This book is confined mainly to film-based monochrome photography because many of the 'basics' concerning camera operation, image capture, presentation and practice are very similar whatever materials or equipment you use. It deals primarily with approaches to photography that are pursued for personal, subjective reasons, rather than to sell a product or service. This does not mean that a great deal of the work coming out of advertising studios and other directly functional establishments is photographically unimportant – quite the reverse. However, the final image is most often as much a product of the skills of others as it is of the photographer, and it can be both difficult and unrewarding to try to disentangle this complex web of visions and motives.

Photography is about communicating ideas and experience as well as information. The camera anchors you to specific locations and concepts, which makes it a superb tool for exploring, observing and representing both the external world and internal reactions to it. In my opinion, only a lens-based medium like photography can do this successfully.

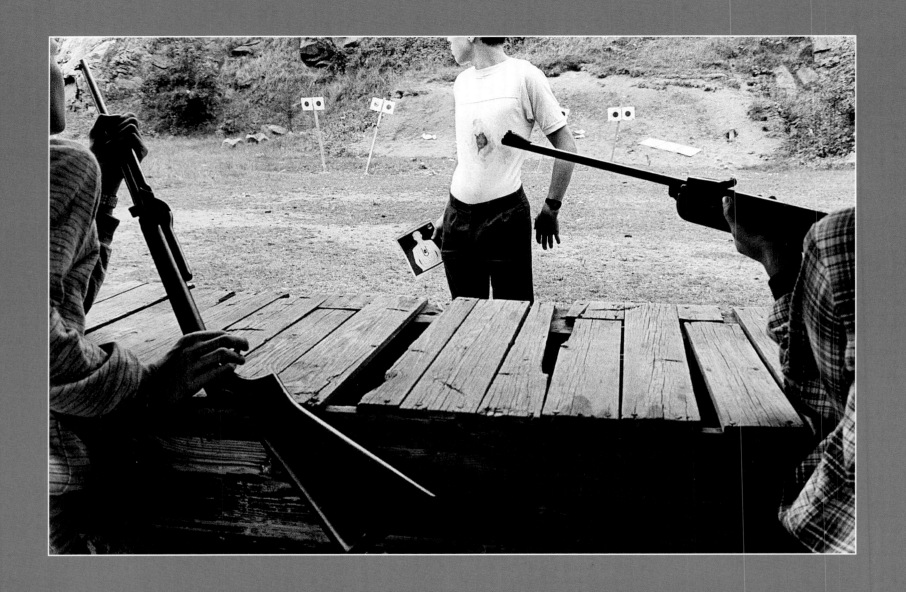

Chapter One: **SEEING AND THINKING PHOTOGRAPHICALLY**

Reading Photographs

Photographs surround us nearly all the time, but we rarely consider that they may have to be read closely before they can be understood. The medium's ubiquity does not mean that it is a successful universal communicator – a sort of visual lingua franca – either. Despite what we are often told, photographs do not 'speak for themselves'. Photography should be considered as a language, which means that its grammar and its syntax have to be learnt before the medium can be fully exploited by the photographer.

Our ability to communicate, as well as our level of understanding, bears a direct relationship to our cultural, social and educational background. These circumstances inevitably affect us when looking at our own and other photographers' work. It is also inevitable that you are going to be influenced most of all – as a photographer – by existing photographs that you have seen. Unfortunately, this can often lead to the frustrating feeling that 'it's all been done before'; but it hasn't by you, and that is an important thing to remember.

There is a tendency to relate the contents of a photograph to your own experience and knowledge, but this is true of most things, not just photography. For example, a photograph of the inside of an artery or an intestine may look to you like a mine shaft or a road tunnel, not the inside of a part of the human body.

Pre-visualization and Camera Vision

Seeing and thinking photographically is different from our normal visual and intellectual processes, so it is important to learn to 'pre-visualize'. The photographer soon learns that the camera provides a view of the world unlike the one produced by the human optical system. It is, therefore, imperative to become familiar with how a camera 'sees'. Also, when you take a photograph, one of the things you do is 'still' a moment of time and a segment of space in front of the lens. This act of 'stilling' is worth further consideration.

Most of us have had to sit still and sketch something at one time or other in our lives. The result may not always have conformed to a

TIME STILLED

Cameras, of course, have the capacity to 'freeze' time and movement, but even when aiming for a candid, caught-on-the-wing picture, you have to be aware of what you are including in the photograph. By placing the camera on a tripod, the process of making photographs becomes a more contemplative and deliberate act of stilling. However, most people adopt an intuitive, instantaneous approach that tends to delay the contemplation of subject and composition until after the camera has automatically 'frozen' the situation. A closer examination of the image takes place when this recorded information is viewed. This is referred to as post-visualization.

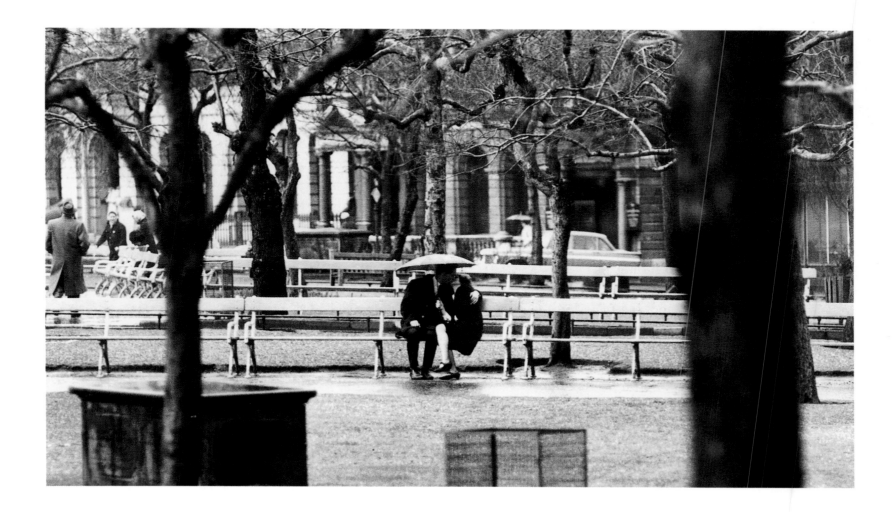

'standard' idea of good draughtsmanship, but the discipline of stilling yourself for a length of time to look closely at an object almost certainly has a beneficial effect. You were probably not aware of it, but you were analysing the structure of the object and the effect light was having on it. You were also making marks. This, in a very general sense, is what you do when making photographs. Once the subject has been chosen, the next step is the two-dimensional orchestration of the elements that make it up – i.e. pre-visualization. This is true in photography as well as in drawing.

Above This photograph shows how the camera can 'freeze' a fleeting moment. Here, a couple embrace lovingly even though they are sheltering from the rain. This candid, observational approach to the medium can, of course, be used in more divisive ways (e.g. by tabloids and for surveillance), but this show of tenderness on a foul day is what the photographer quickly spotted and realized would make a bittersweet image. The umbrella, not the embrace, draws the eye first, but the combination makes the picture work because it tells the story without the need for any text. **PAUL HILL**

The Frame

Photography is a very subjective medium despite the apparently objective way it represents what is before the camera. The photographer, after all, controls when the exposure is made, how much light falls on the film (or sensor) and, most importantly, what is included in the picture. The latter is defined by what you frame within the perimeter of the viewfinder.

It might prove an interesting exercise to hold a picture frame out in front of you. Then, imagine that everything you have framed is monochrome and flat. This is the sort of transposition you have to make when taking photographs. What happens outside the frame may be important too, but once the photograph has been taken you can only speculate upon that. Similarly, the photographer cannot photograph what is not there, but the viewer may have to consider what the photographer leads him to believe is happening in the picture. Your reading of a photograph is usually governed by what you want to see in it; in other words, what your cultural and educational background dictates is 'there'.

Photographers can never foretell what other people will make of their images, but they have to be conscious of what they are doing and the effects their photographs can have. Remember that the photographer can choose which part of the world to 'still' forever, whether it is the expression on a person's face or a certain section of a particular landscape. This is a great responsibility, especially when the results are for public consumption.

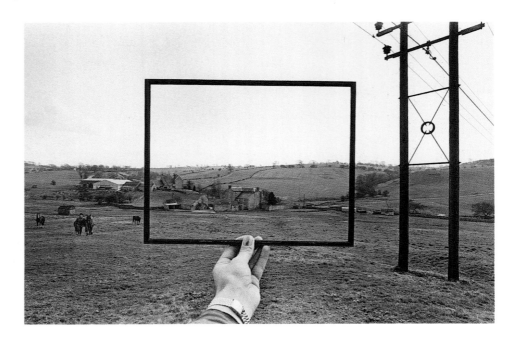

Above/Below When you take a photograph, you isolate a segment of the world as if you were placing a frame over the part that interests you. Framing a photograph is a subjective act because you include what you want and exclude what you consider unnecessary. The frame of the viewfinder and the type of lens used dictates what you see photographically. **PAUL HILL**

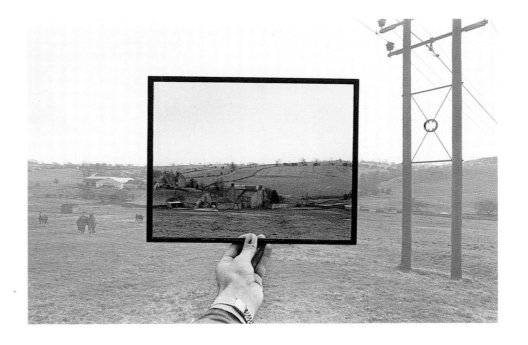

Lenses and Angles

The frame gives a discipline to work within, but it should not intimidate. To achieve greater freedom of vision, try using different lenses. Try a wideangle lens if you want a wider field of vision, or if you want to isolate or compress things in the middle or far distance, experiment with a lens that has a longer focal length. But while it is natural to test different lenses in order to explore the options available, be aware that distortion and gimmickry can occur and get in the way of the idea you are trying to convey in an image.

Below If you want to widen your field of vision, you should use a wideangle lens. Among other things, this gives the picture a feeling of space and depth. This shot, taken on a 35mm camera using a 21mm lens, enhances the strange spectacle of Cumberland wrestling (at Grasmere Sports Day) by including the majestic sweep of the surrounding Lakeland mountains as well. A normal lens cannot achieve the dramatic optical effect of the wideangle. Ultra-wideangle lenses can distort hideously, but if used carefully they can greatly enhance the visual dynamics of the photograph.
PAUL HILL

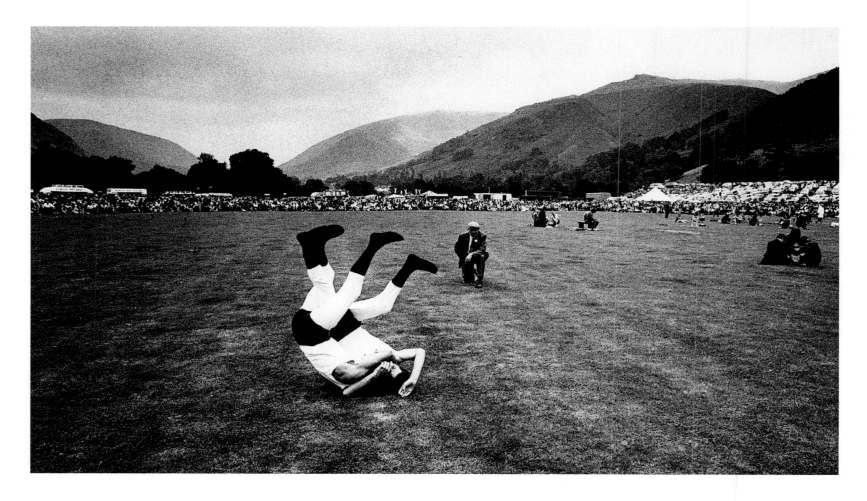

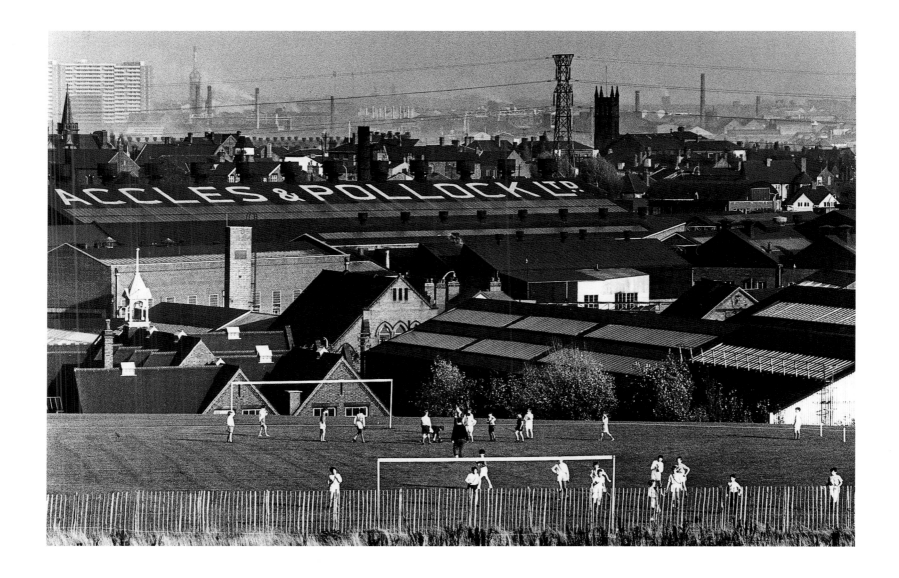

Even a standard lens (usually 50mm on a 35mm camera) can escape its seeming conservatism if you shoot from different angles of view, such as looking up or down. Don't put the camera to your eye all the time; put it on the ground or hold it above your head. There is no law that says the world should be seen from a level between five and six feet above the ground.

Above In order to include as much information as possible in the viewfinder, you can use a telephoto lens. In this picture, taken near Birmingham, there are factories as far as the eye can see. Despite the complex information contained in the photograph, small pockets of land turned into playing fields can be picked out. The 180mm lens (on a 35mm camera) used here appears to 'stack' the factories on top of each other, as well as compressing foreground and background together.
PAUL HILL

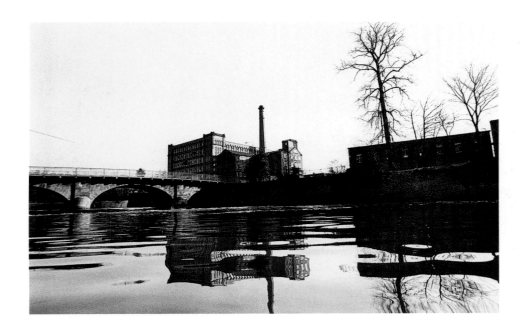

Left and Below Taking photographs while pointing the camera up or down can produce some interesting results. Here, the camera was placed at the same level as the River Derwent in Derbyshire by dangling it over the embankment (as you can see from the end of the fishing rod on the left of the picture). Unless you have a waist-level viewfinder, you will have to guess what is in the shot.

The lower picture shows how the use of a high vantage point can alter our perception of what appears at first to be an innocent scene. In this case the photograph was taken from the window of a high-rise building, but due to its intriguing composition it could be interpreted in many different ways, some of them sinister. **PAUL HILL** and **RICHARD SADLER**

'There is no law that says the world should be seen from a level between five and six feet above the ground.'

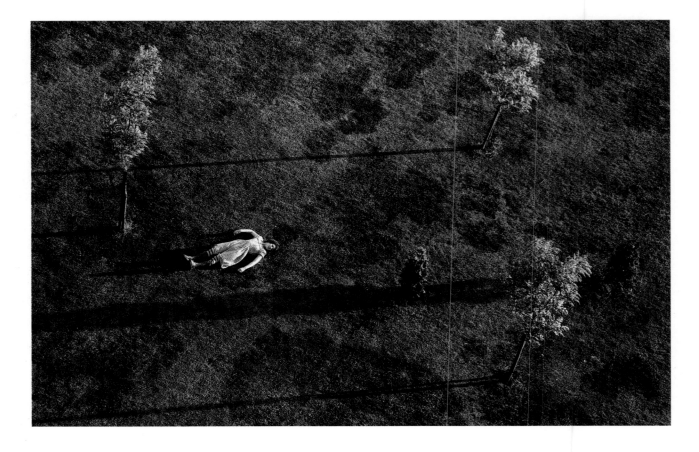

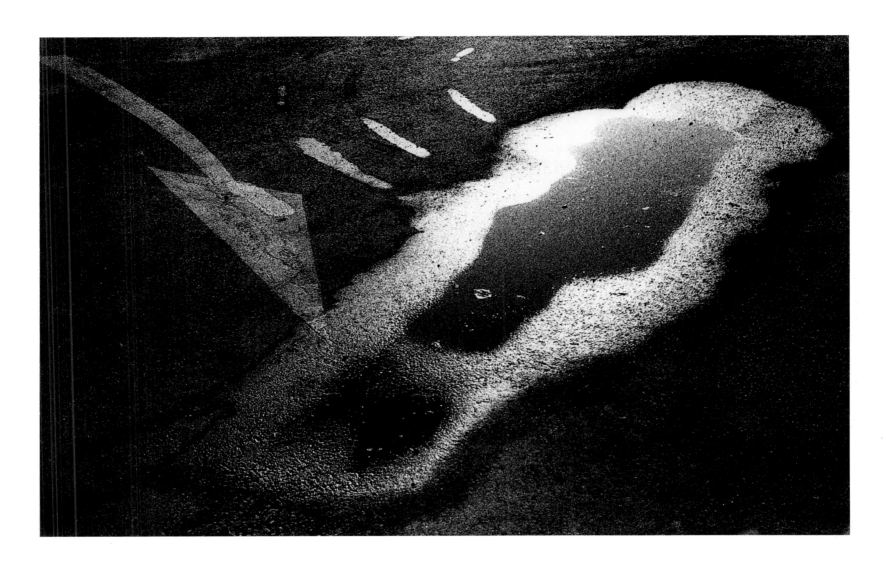

Tones

In black & white photography, all things become monochromatic tones residing on the same plane. Actual colour and space do not exist; the camera can only record the light reflected off the subject matter that the photographer has framed. In a photograph, the separation of the tones – these are actually grey, not black & white – results from the varying intensities of light reflected off the different

Above In black & white photography, reflected light is translated into monochrome tones and a subject is defined by the amount of light it reflects onto the photographic film. The puddle of water, the painted white arrow and the wet tyre marks are the same tone (the tyre marks could easily be mistaken for painted lines), although they are very different objects in reality. **PAUL HILL**

objects in a picture. You can see this when you photograph two differently coloured objects that, according to your meter, reflect exactly the same amount of light. In a photograph, these two objects may appear to be tonally identical:

'Actual colour and space do not exist; the camera can only record the light reflected off the subject matter that the photographer has framed.'

something green and something blue could produce the same grey. The photographer has to decide what tones the objects in a photograph will be – another subjective decision.

'Flattening' the 3-D World

The camera frame gives the illusion of being a window through which the photographer views the three-dimensional world, but negatives and prints are two-dimensional. In a photograph, the clouds, the horizon and the ground are all on the same plane. Our perceptual faculties can, of course, make three-dimensional sense of this spatial disparity while looking at a print. When making the photograph, you must be conscious of the fact that the objects in the picture will be flat shapes, and that you are responsible for the placement of these shapes within the frame. By changing your angle of view and viewpoint you can manoeuvre these forms around the frame almost as if they were cut-outs in a collage.

Translation of the objects in your photographs (this can include evanescent objects like shadows and clouds) into shapes and tones does not come easily, but it can be developed with practice.

Facing Page A photograph brings everything in front of the camera onto the same plane. The 'flattening' of the three-dimensional world can be exploited by appearing to place distant objects onto objects in the foreground. Here, the photographer has positioned himself and his camera with great precision to bring disparate elements together and produce a very witty image in which trees appear to balance on a chain-link fence. **JOHN CHARITY**

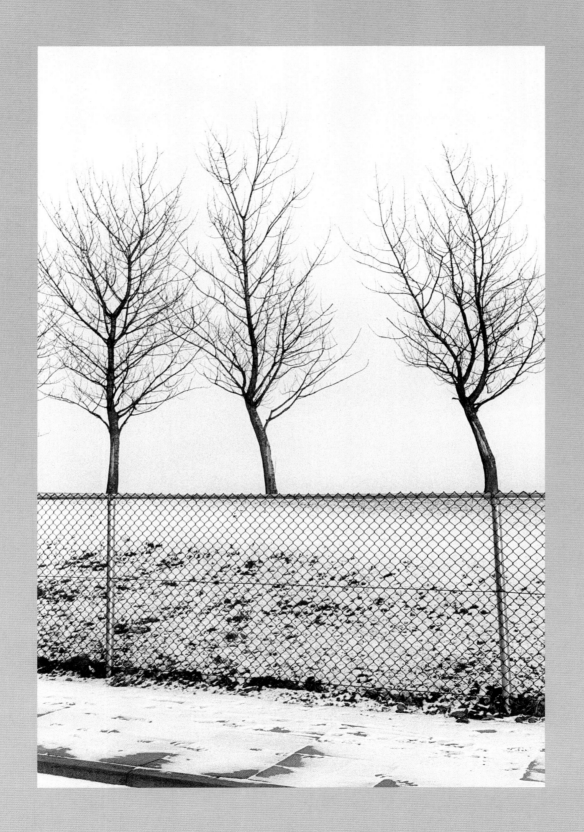

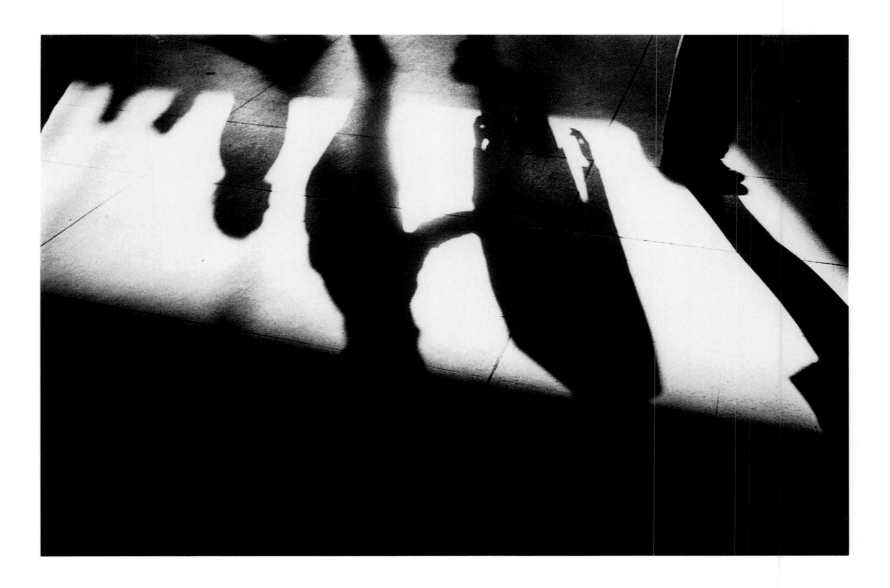

Above Shadows and light reflected off this shopping-centre floor may seem rather uninteresting, but the ephemeral and evanescent are just as 'concrete' as mountains or buildings to the camera. Shadows can hint at the fearful and mysterious, or they can make interesting graphic shapes. **PAUL HILL**

Illusion

A good example of how totally unconnected objects (shapes) can appear to exist on the same plane is the classic photographic 'mistake': the human head that has a tree or lamp-post growing out of it. Most people are aware of this apparent compositional faux pas, but few photographers use it to their advantage. There are no rules that say you should not give the illusion of strange things growing out of people's heads. As a two-dimensional record of reality, the photographic print is an illusion anyway.

The Focal Point

When you compose a photograph it is usual to concentrate on a focal point, often a figure or some significant form you want to be the main subject. This focal point becomes separated from the background because the brain always tries to organize and make sense of the visual disorder in front of it. But just because you have isolated the form (this could be a small part of the picture) in your mind does not mean that this will be obvious in the final photograph. At this point, consider what is happening in other parts of the viewfinder.

Right Similar tones in black & white photography can merge despite the fact that the subject you photographed consisted of very different objects. Here, the hindquarters of the horse 'disappear' into the side of the caravan. **PAUL HILL**

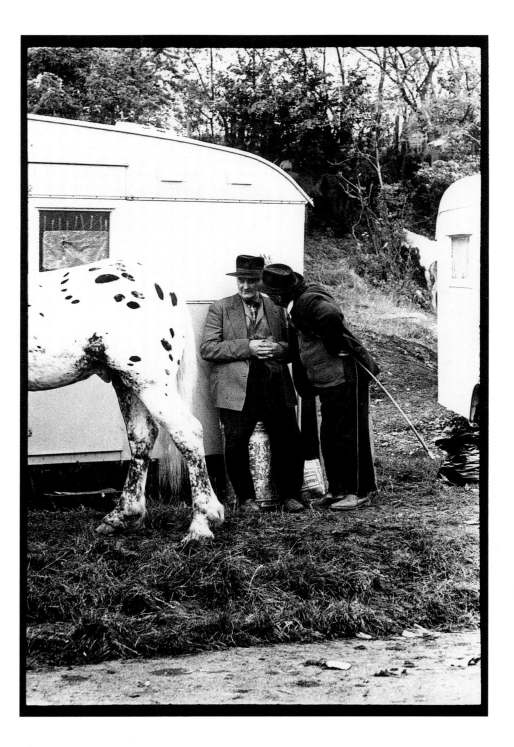

Below One of the best ways to isolate your focal point is to place it in approximately the centre of the frame. Here, the dark stain on the boy's T-shirt obviously attracted the photographer at this rifle range. The rifle barrel on the right also helps lead us to the ambiguous mark on the shirt, which could easily be interpreted as blood, thus imbuing the picture with a more sinister overtone. **GREG LUCAS**

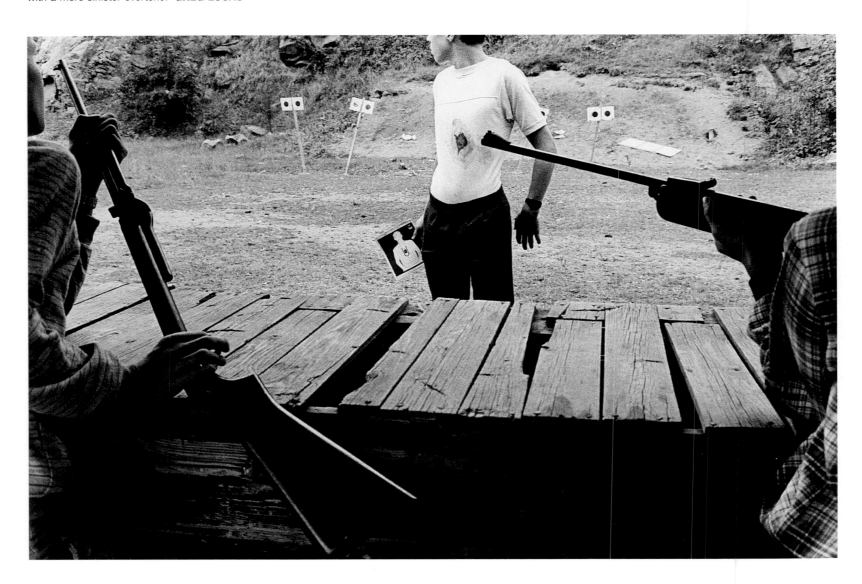

Remember too that your picture-plane includes the background. Its intrusion may not be obvious to the human optical system, but in a photographic print the tones that make up the background may contain visual 'traps' that our eyes have difficulty escaping. This may affect the reading of the picture so much that it alters the scene completely. For example, if a dark subject merges into the dark tones of the background it will be lost, and vice

'When making an exposure, always try to imagine the resulting print in your mind's eye.'

versa with light subjects and light backgrounds. Of course, you may be able to 'save' the situation in the darkroom by manipulating the tones when printing, but if the tones of the subject and the background are identical this is very difficult. Anyway, why create extra work for yourself? When making an exposure, always try to imagine the resulting print in your mind's eye. By doing this you can avoid problems later.

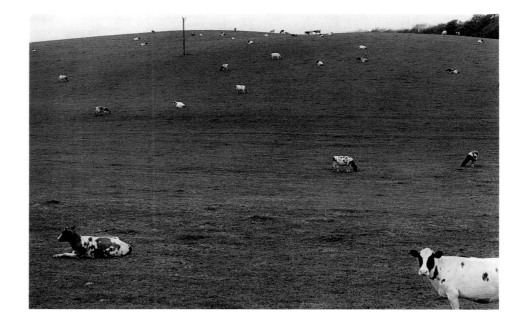

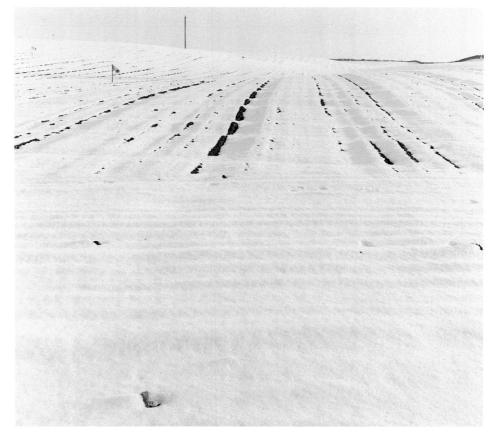

Right These two photographs show the subtly dynamic effect that can be produced by small, light shapes placed against a dark background, or small, dark forms on a light surface. A herd of remarkably 'arranged' cows in a field, and clods of ploughed earth peeping through a blanket of snow, are the unlikely visual highlights in these fascinating images.
RAYMOND MOORE

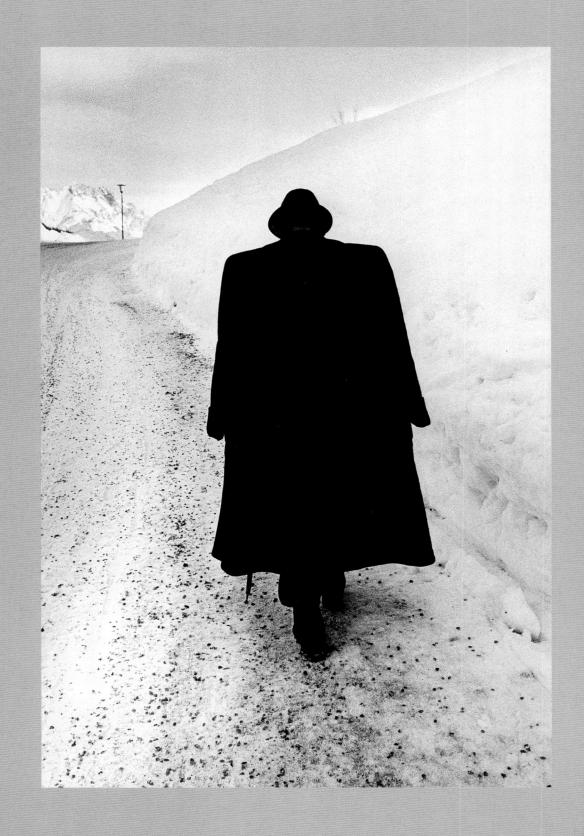

Metaphors and Symbols

Just as writers use descriptive adjectives and similes to express their reaction to things, so photographers communicate their feelings by the way they photograph the world around them. But with photography the metaphor is not always clear; images do not convey meaning with the same precision that words do. By photographing a building or a tree, can you show more than a building or a tree? On the surface it would appear not, but just as a photograph of a face can reveal the identity of an individual more clearly than a full-length image, it may be possible for a close-up detail of a building or tree to express more than a

'By photographing a building or a tree, can you show more than a building or a tree?'

picture of the whole. The 'substance' of an object can be conveyed most strongly by moving in closer, until there is an almost tactile relationship between the photographer and the subject. The close-up abstracts by cutting out the extraneous information through careful framing. You may want to take a close-up photograph of an institutional building to convey monumentality or coldness. With the detail of a gnarled tree you may wish to express delicate sensuality or painful convulsions. A caption (or title) can help direct the viewer to an understanding of your metaphoric intent, but should never become a substitute for it. You should always aim to express the metaphor visually by careful use of exposure, juxtaposition of objects, and lighting.

It is possible for close-ups to symbolize something more than what is actually recorded on the film. In photography, the objects become symbols because a symbol is a visible sign that represents or typifies something else. This is a reasonable description of what the process of photography does – the photographic image of a tree is not the tree but a symbol (or sign) for it. But, in addition, if the picture shows a tree isolated in a flat landscape, it could also be said that the tree symbolizes something else – loneliness or isolation.

Juxtaposition

Another powerful way to express feelings or opinions in photography is by juxtaposing objects and elements within the picture. Dark tones, like shadows, against light backgrounds can evoke mystery and fearfulness, light and dark can represent good and evil, and so on. Juxtaposition can also heighten the incongruity and absurdity that is apparent in certain situations.

Awareness

Care in pre-visualizing can save hours of needless work in the darkroom. Of course, there is a danger in being over-precise when photographing, especially if you want to follow a more flexible, experimental approach. But even in this type of work you need to analyse what you are doing carefully if you want to repeat the effect of an 'accidental' image.

It cannot be emphasized too strongly that a great deal of practice is necessary to get the results you want. If you use a handheld manually operated camera, handle it as much as you can, whether there is a film in it or not. With manual cameras, get used to the viewfinder, the focusing and the aperture ring, even at times when you are not taking pictures. Practice makes musicians know instinctively how to get the notes they want from their instruments, and photographers should aim to be equally assured.

A continuous awareness of light, from the aesthetic as well as the technical point of view, is vital in photography. When you go into a room, judge how the light is falling, estimate the light reading (confirm this with your exposure meter later) and assess the probable photographic tones and shapes of whatever you look at. You should continually try to heighten your awareness of what is going on around you, and of your own reactions and feelings towards people, things and events. The camera should be an ever-present part of your life, available to be used at any time and anywhere.

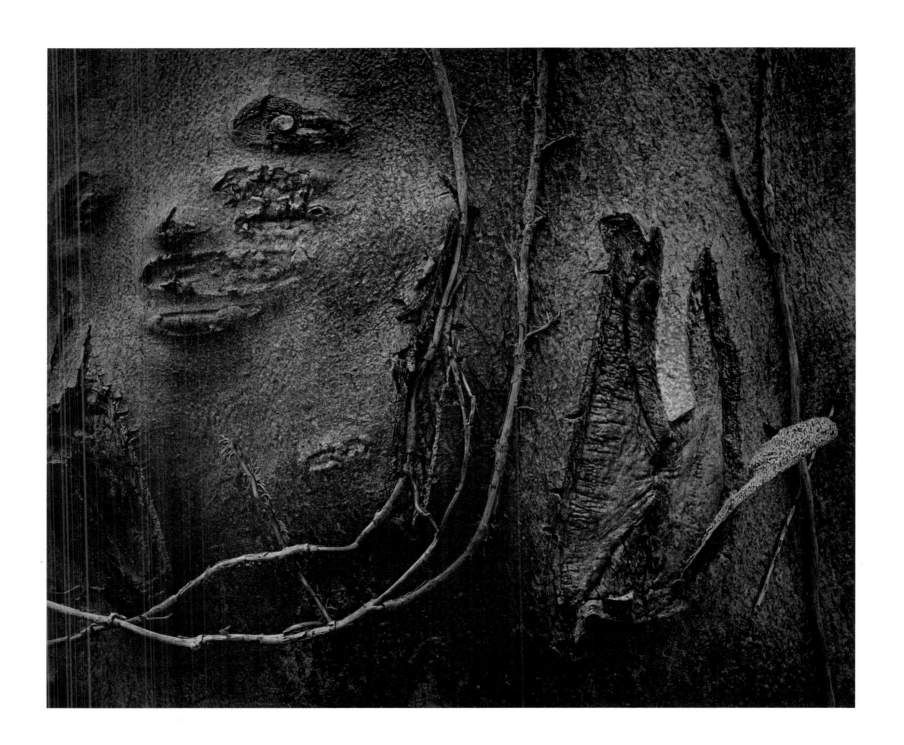

Try to master the basic photographic techniques as quickly as possible because this leads to more control and understanding of the medium. Do not blame the mechanics and materials if you are not getting the results you want. If there are problems, find out what is going wrong. Try to understand what you are doing with photography – and what it is doing to you. Most of the answers will become apparent at the next stage: post-visualization.

Below 'Accidents' can produce creative breakthroughs, both in science and the arts. Many photographers discovered that using electronic flash with a slow, unsynchronized shutter speed produced 'ghosting' in their pictures. This was because the subject either moved during the exposure or the photographer did, or both. The cat appears to be casting a shadow against the sky, which looks like a theatrical backdrop. **PAUL ERIK VEIGAARD**

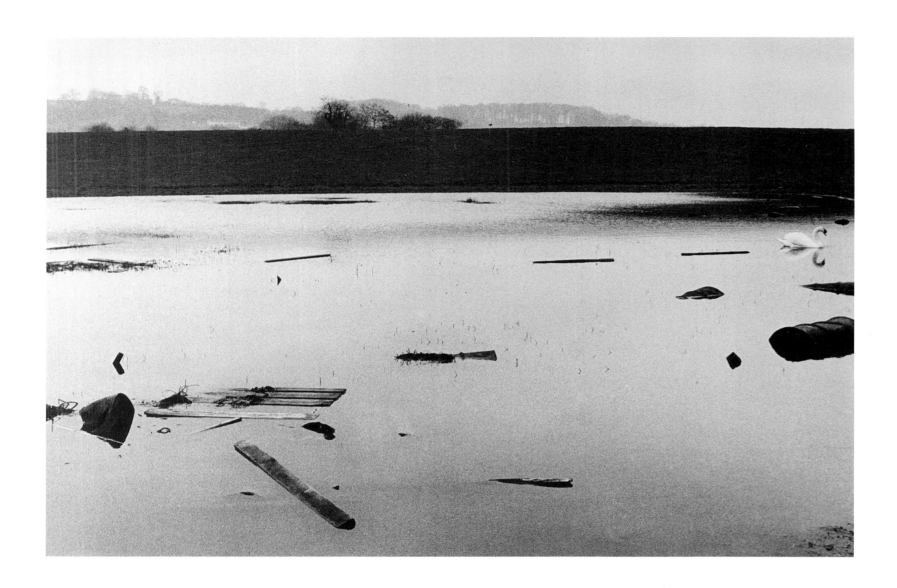

Above Juxtaposition is one of the most powerful devices used in photography. The pure white swan floating among the dirt and flotsam of this pool emphasizes the effect such indiscriminate dumping of rubbish can have on a beautiful landscape. The way that the photographer has placed the swan in the frame (he relies on the light tones of the bird, rather than its size, to make us aware of it) prevents the picture from being compositionally 'safe' and conventional.
DAVID HURN

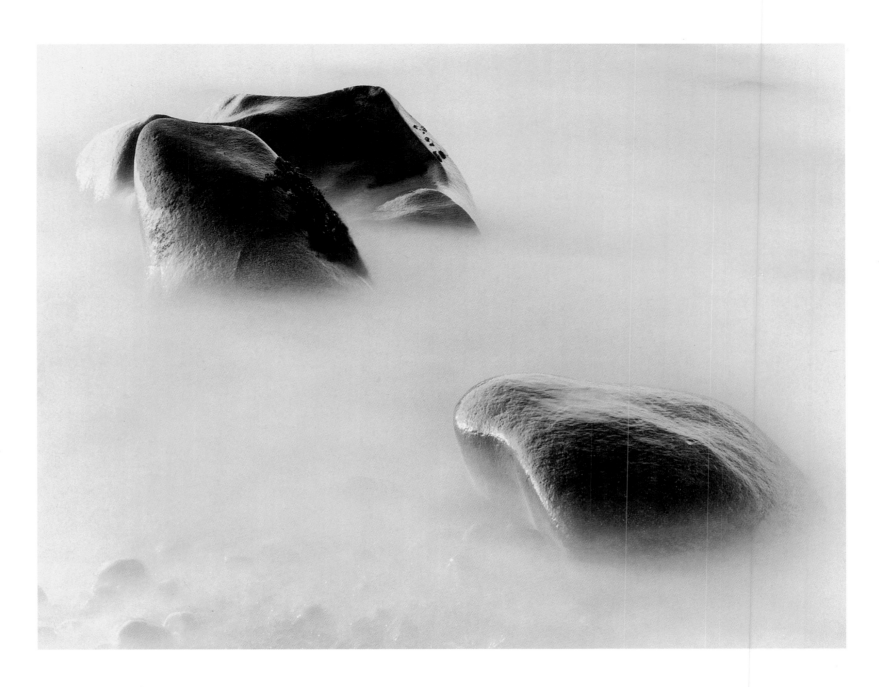

Above Another photographic phenomenon is the mist-like effect you can achieve by using a very slow shutter speed while photographing movement, such as waves crashing on rocks. In this picture, the 'whale-like' rocks have been isolated by the photographically induced 'fog'.

JOHN BLAKEMORE

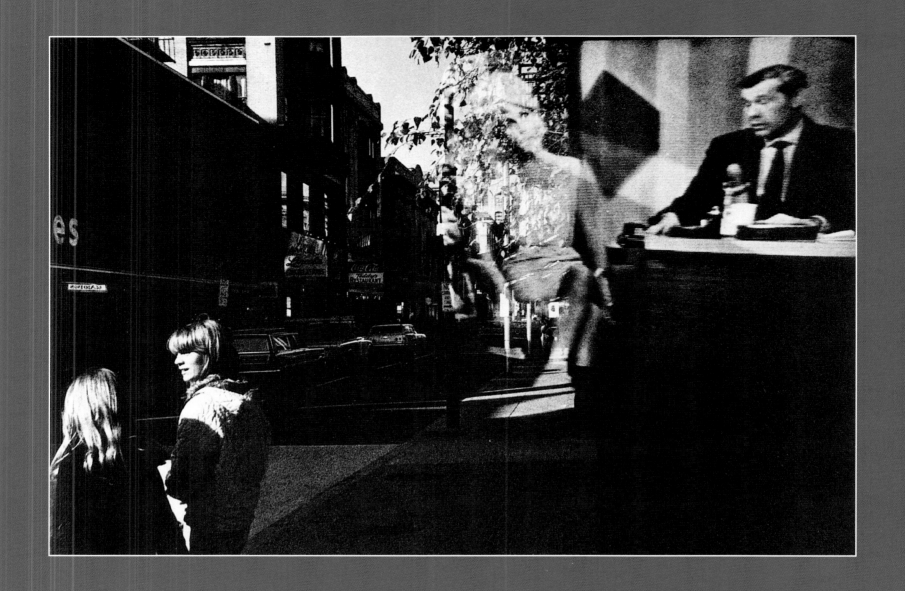

Chapter Two: **AFTER THE SHUTTER IS PRESSED**

Reading the Negative

In conventional photography, you cannot make an image of what is not there. Similarly, you cannot print what is not in the negative. If the film has been over- or underdeveloped, it is almost impossible to obtain good prints from it. There are several ways of salvaging bad negatives, but making silk purses out of silk is always preferable to making them out of sow's ears!

'Reading' negatives is as important in the photographic process as translating the three-dimensional world into two dimensions and colours into monochromatic tones. With practice, it does not take too long to convert the negative into a positive instantaneously in your mind's eye. It soon becomes second nature.

After a while, you will be able to obtain as much, if not more, information from your negatives as from the positive contact prints ('contacts') of your films. Shapes and tones become easily discernible,

'The negative is the most important technical thing to get "right" in photography that uses chemical processing.'

although some important aspects, like facial expressions, are much easier to read from contact prints. The negative is the most important technical thing to get 'right' in photography that uses chemical processing.

LIGHT AND DARK

Remember that the darkest (densest) parts of each negative are rendered as the lightest parts (highlights) in the positive print. This includes areas such as the sky, snow, light-coloured buildings and blond hair. Conversely, the more transparent (thinner) parts of the negative become the dark areas in the print. This includes subjects such as shadows, earth, dark-coloured buildings and dark brown hair.

When enlarging your negatives in a conventional darkroom you will find that it is easiest to print those that contain the widest range of tones from the darker areas through to the highlights. In some cases, you may want a negative that accentuates the highlights to produce a picture that has a particular graphic quality. This effect can be created through overexposure and/or by increased development. This 'blocks up' the highlights to make them denser in the negative and consequently lighter in the print.

You can also diagnose errors of exposure, camera operation, focusing and depth of field by closely examining your negatives on a light box or projected by an enlarger.

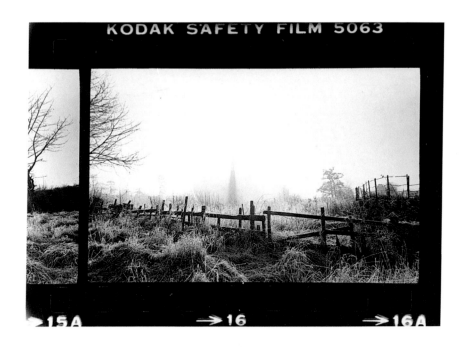

Left and Below Once you have learned to read them, negatives can give you more technical information about your photograph than your contact sheet. Here the 'contact' of frame 16 gives no idea of the wealth of information that is contained in the upper half of the photograph, but it is visible in the negative and, therefore, you know that you can reveal it in the print. **PAUL HILL**

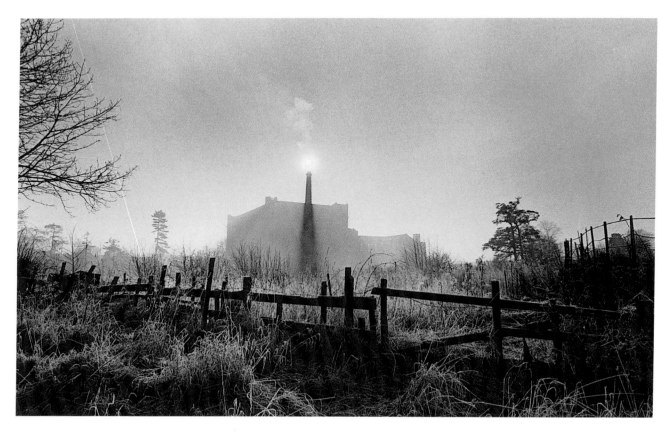

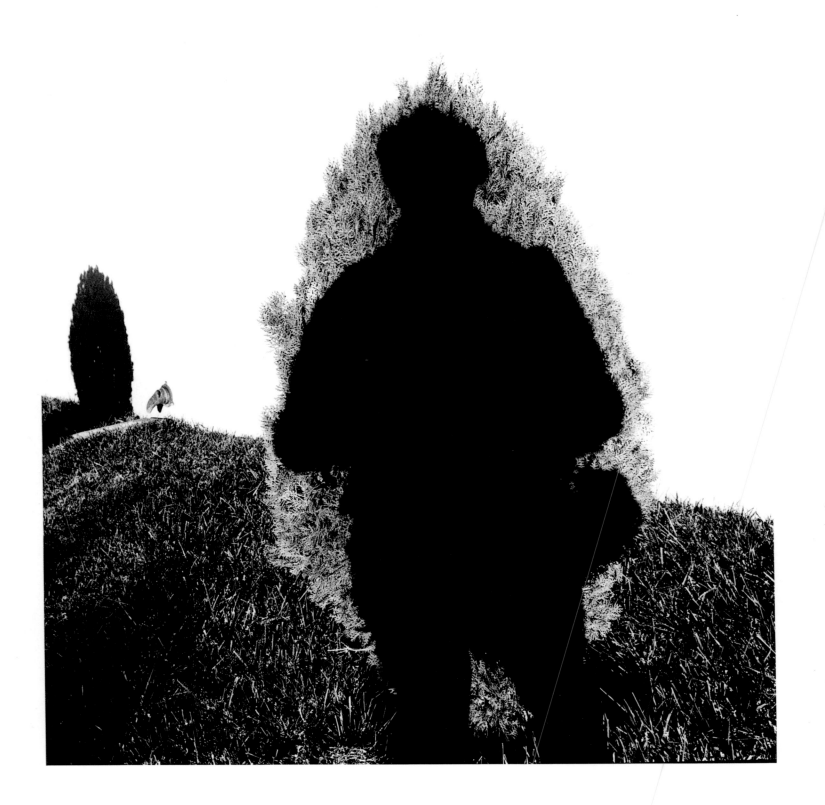

Facing Page 'Blocked-up' highlights (in this case a brightly lit white wall) have been used to isolate the bush (with the photographer's shadow cast on it), the grass, a waterspout and the shadow of another bush. Graphic manipulation also eliminates the frame because the highlights and the base white colour of printing paper are indistinguishable. Many photographers put a funereal black border on their pictures to correct this, but this self-portrait emphasizes the frame's conventionality by removing it almost altogether. **JOHN MULVANY**

Right Overexposure and/or overdevelopment can 'block up' (make denser) the darker parts of your negatives, so that no light penetrates those parts at the enlarging stage. These featureless white elements in the print can be used as graphic or, in this case, emotive devices. **PAUL HILL**

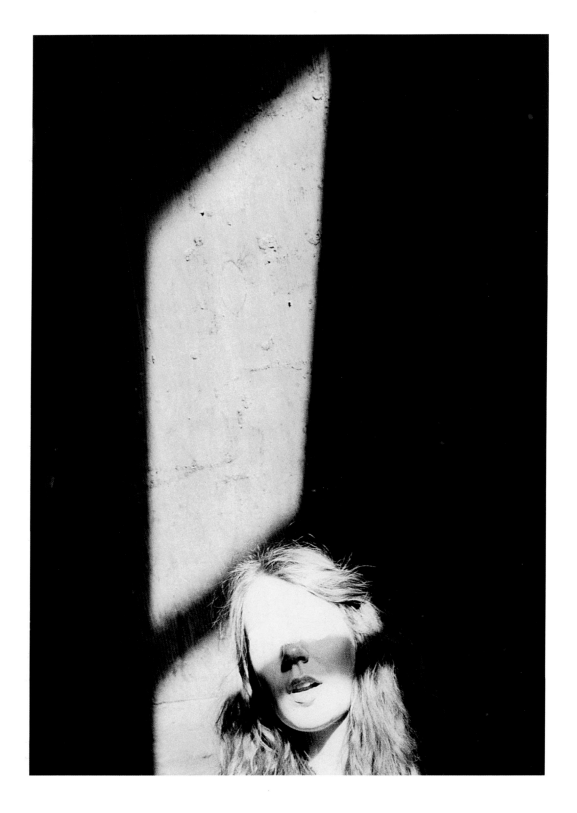

Contact Prints

When you make an exposure you are attempting to 'capture' an image that makes some sense out of the welter of information in front of you. No matter how careful you are, there are bound to be many unknown quantities in your pictures. Your success or failure becomes evident when you read your contacts in print form (or 'thumbnails' on a computer screen, if you are using digital equipment). Just as you had to make a choice of what to photograph, so you have to select from the contact sheet the images that correspond most accurately to your intentions.

The first shot is rarely the best: your concentration usually improves as you warm to the task and your awareness is heightened. Contacts are a particularly accurate reflection of your working methods and experiences; as well as being a record of the exposures made, they provide visual narratives of your adventures and achievements. In fact, many photographers use their contact sheets as diaries; they become a souvenir of places, people and events, which will be interesting to look back upon in years to come.

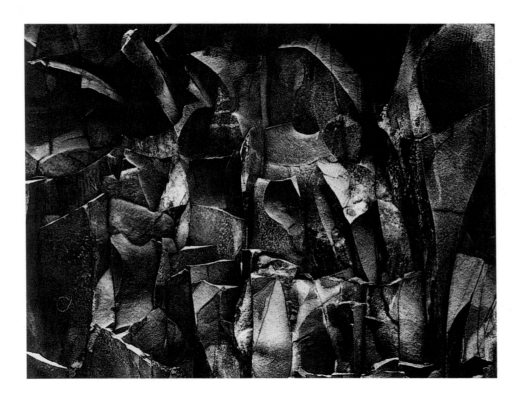

Above This photograph is a wonderful example of how photography can abstract tones, forms and lines, even from an 'ordinary' subject such as this quarry face, and make them into an exciting, almost animated image. Not only is the full range of tones in the grey scale represented in this picture, they are positively celebrated by the photographer.
PAUL CAPONIGRO

Ambiguity

One of the first things to strike you when looking closely at photographs is the ambiguity of the medium. Some objects appear completely different to what you know they were in reality. For example, people reflected in a furniture shop window can seem to be walking on a sofa, or the

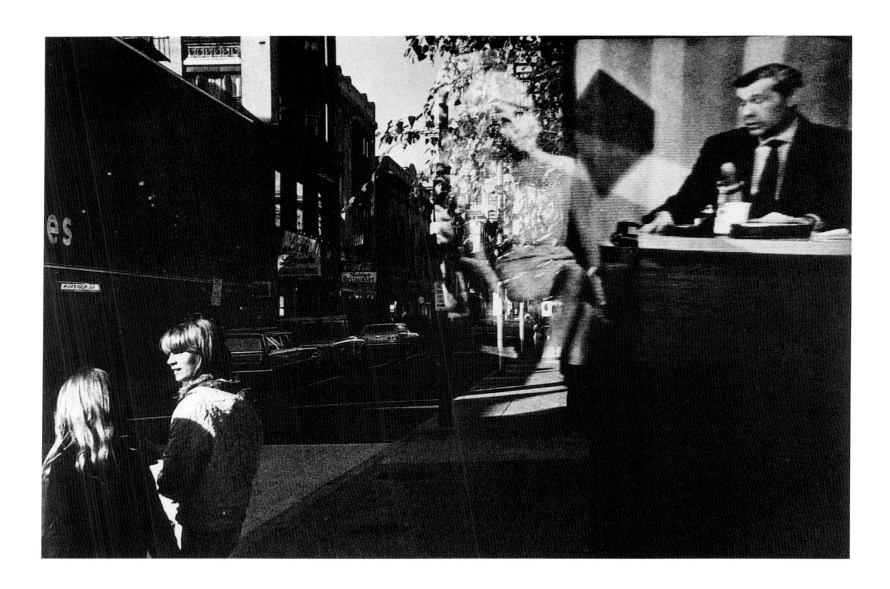

strange play of light on the face of a kind old lady can turn her into a hideous crone.

It is very easy to miss these things at the time, especially if your eye was concentrating on other compositional features, or if you were eagerly following the event or incident that was your main subject. Remember that a photograph shows what the camera records, not what you thought you saw.

Above Strange things can often appear in photographs that you could have sworn were not there when you took them, probably because you were concentrating on other things when you pressed the shutter. Ever-alert photographic artists notice these strange events, but many people would not see such oddities. This is evident in this photograph of a street scene, where the reflected television picture of an actress on a talk show is apparently floating over the sidewalk.
HARRY CALLAHAN

Enlarging

Post-visualization should not only make you aware of these phenomena, but also help you to deal with them. If you have included elements in your photograph that you do not want in the final picture, it is possible to eradicate or hide them at the printing stage. One option is to crop them out by manoeuvring your masking frame under the enlarger in the darkroom. Another is to lighten or darken the objects (by 'burning' or 'dodging') so that they disappear into the background. Unwanted elements can also include scratches, out-of-focus foregrounds and other mistakes, as well as the kind of visual 'traps' mentioned earlier.

' ...the photographic print is an event and experience in itself, not just a record of what was happening in front of the camera.'

The more you become involved in photography the more you realize that the photographic print is an event and experience in itself, not just a record of what was happening in front of the camera. The photograph should not be expected to mirror truth, because 'truth' in visual terms is always subjective.

'The camera never lies' is one of those sayings that should be buried and forgotten. You must look at what is in the negative and in the print and deal with that, rather than try to reconstruct your mind's eye vision of what you thought was there. It is important to try to find out, for instance, why the print does not contain the essence of that person, event or the thing you thought you had captured when you pressed the shutter. When you take photographs you are also in a continuum of events affected by all kinds of external and internal factors, so you must try to eliminate all extraneous things from your mind and concentrate on the image that you want to be the print.

The Print

The print is almost always the final stage in the production of the photograph. It is the means of showing your view of the world to others. But communication will not take place if your printing lets you down. What you saw at the moment of exposure and what you have read in your negative must be transmitted through the prints.

In printing you have to control light (through the enlarger lens, as mentioned previously) in the same way you do when exposing a negative in the camera. This can affect the tones in your prints, as can the contrast of the paper you use. The quality and characteristics of the photographic paper you choose is also most important (see *The 'Fine' Print*, chapter 6, page 110).

A Theme

After a while, you will notice that certain features keep repeating themselves in your photographic work. Perhaps you often shoot things from the same angle or from the same distance. Perhaps you photograph similar types of individuals, events or places. It could be that the same mood or atmosphere occurs time and again in your images, or similar shapes and forms become repeating motifs. Try to discern from your photographs what may be an emergent theme. A theme may have more to do with the way you photograph than with what you photograph. In other words, the way you see the world – your individual vision.

(a)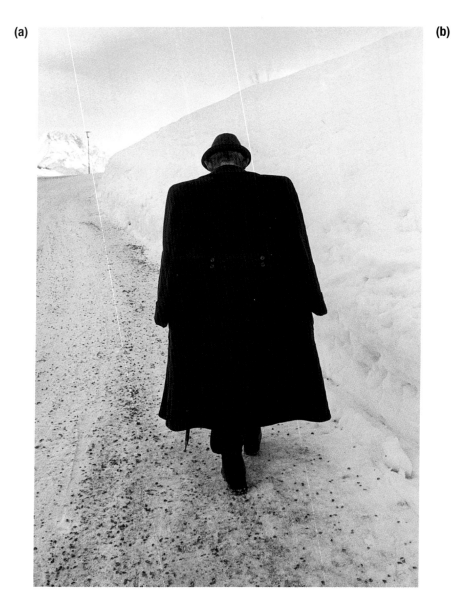

(b)

Above Left and Right Many forms of printing manipulation can be undertaken in the darkroom (or on the computer) in order to produce or enhance the 'message' emanating from the photograph. For example, the contrast between the tones can be increased and a certain amount of 'burning' and 'dodging' employed to change **(a)** to **(b)**. This was done to accentuate the two-dimensionality of the black form, thus increasing the odd and somewhat fearful quality of the image. **PAUL HILL**

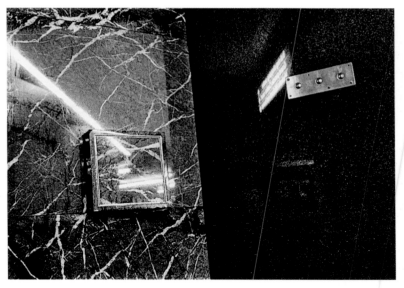

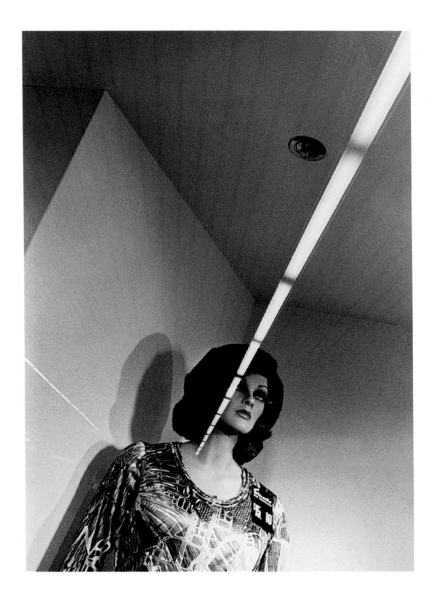

Above and Left These two photographs come from a sequence called *Light*, which aimed to convey the many forms in which light manifests itself – even in the most ordinary of situations. Visually dramatic evidence of light can be found in places like high-street stores, arcades and malls. In these examples, reflected neon lighting can appear to be like a white arrow-shaped beam penetrating a marble wall or a shop-window dummy. Although the theme was 'light', these two images show how subsidiary concerns can reinforce the cohesive quality of the sequence, and thereby add extra elements to it. **PAUL HILL**

Your ideas and concerns, if focused on a particular subject, will be like a piece of grit in an oyster around which your work will begin to grow. Eventually, a coherent body of work will emerge. But it takes time for a pearl to form – and not every oyster produces one. However, beware of superficial success and easy results. You may produce a series of photographs that are slick imitations of current fads and fashions. If so, do not stay at this imitative stage for too long.

Sequencing

Photographs are signs and symbols for ideas, and by conscious and careful arrangement (or 'sequencing') they can convey specific concepts. The order and positioning of your prints when displayed – either on a wall or in a publication – are crucial to the communication of the statement you are making through your work. Although the statement may be made up of many different elements (including single prints that can also work on their own), the sequence should have an overall unity and effect, whether it is a realistic or abstract subject. Unity can be achieved by the repetition of shapes and tones as well as by the use of recurrent symbols or objects. Ephemeral and solid objects from the 'real' world can have the same visual status in a photograph, and this leads to many creative options for the photographer.

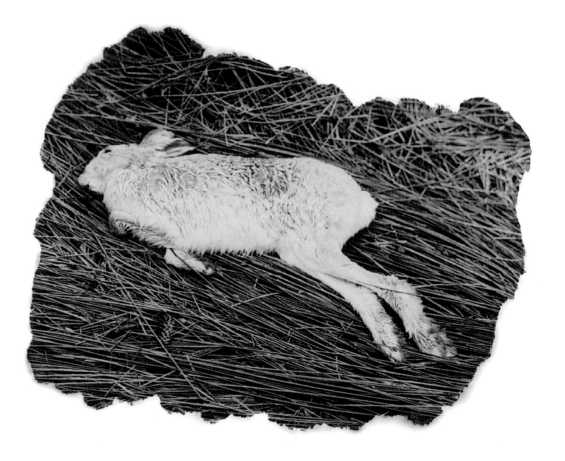

Above The shape and framing of the print can also be a repeating motif in a sequence. This image of a dead mountain hare has been made using a cloud-shaped mask during printing. The work hopefully has more than an unusual format or presentational quirkiness to commend it. **PAUL HILL**

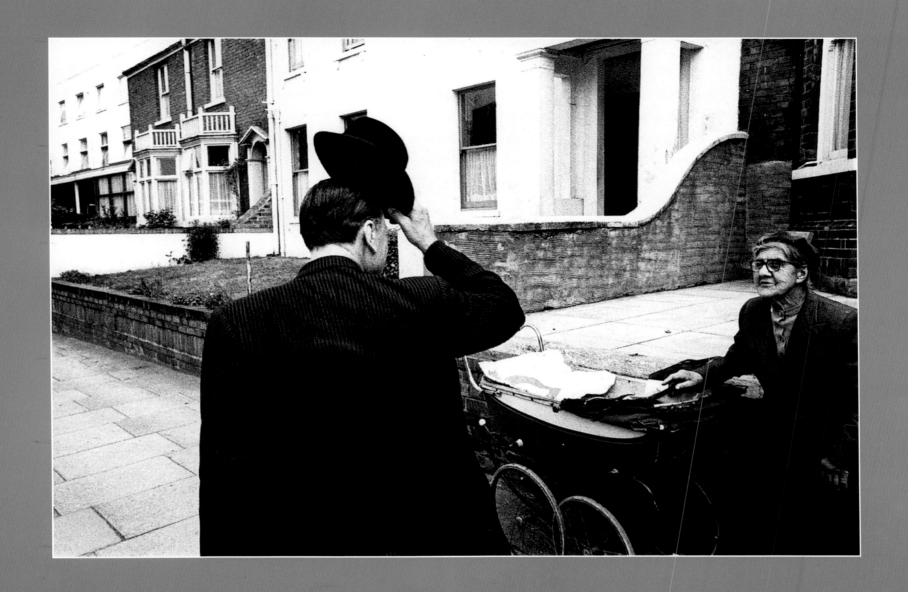

Chapter Three: **ART AND COMMUNICATION**

Early Developments

The concept of photographic representation was appreciated hundreds of years before the process of photography was discovered. The development of the theory of perspective in the fifteenth century gave drawings and paintings the illusion of three dimensionality in the same way that photographs do. This proved a wonderfully successful technique for the painters who wanted to improve accurate representation. As a result, the camera obscura was used to project a light-reflected image onto a flat surface, which could be traced with a pencil or pen by the artist. The image became sharper when the aperture allowing the light in was smaller or, better still, if the light was focused through a lens.

These devices were particularly popular among amateur painters eager to find a quick, foolproof way to emulate the work of their professional peers who possessed the accurate draughtsmanship and skill that they lacked. But many prominent painters like Canaletto also used the camera obscura, and so did the Victorian scientist and amateur painter Henry Fox Talbot, the man who invented the negative/positive method of photography that we mostly use today.

Influence of Photography on Art

The invention of photography released painters from their representational role, which meant the more perceptive of them could pursue their investigations into the nature of their medium and the act of painting. Photography had an enormous effect on the artists of the nineteenth century, as it still does today. The realist painters, like Millet and Courbet, were seemingly affected; after all, their motto was 'You cannot paint what you cannot see'. Out-of-focus and blurred photographic images interested the Impressionists (whose first exhibition, in 1874, was held in a studio lent to them by the Parisian photographer Nadar), as did the capturing of fleeting human gestures and positions, and the interesting way in which the photographic frame cropped the image. Multiple images and frozen movements were two of the photographic phenomena utilized by modernist painters in the early twentieth century. Photography has been an important factor in the development of surrealism, Dadaism and the more recent photorealist, conceptual and postmodern movements.

WHAT IS ART?

The French painter Debuffet said of art: 'Its best moments are when it forgets what it is called.' Although photography is a unique medium, it has always been compared with the more obviously handcrafted arts, like painting. Even today, many people are still concerned with the question of whether or not photography is an art.

Below One of the most successful 'artistic' photographers of the nineteenth century was **HENRY PEACH ROBINSON**, who produced many salon-acclaimed works that owed much to Pre-Raphaelite painting (although it must be said that many Pre-Raphaelites were, ironically, accused of copying photographs in the early 1850s). Robinson 'constructed' his photographs and this famous picture, called *Fading Away* (1858), was made up of five different negatives printed in combination. *(Courtesy of the Royal Photographic Society)*

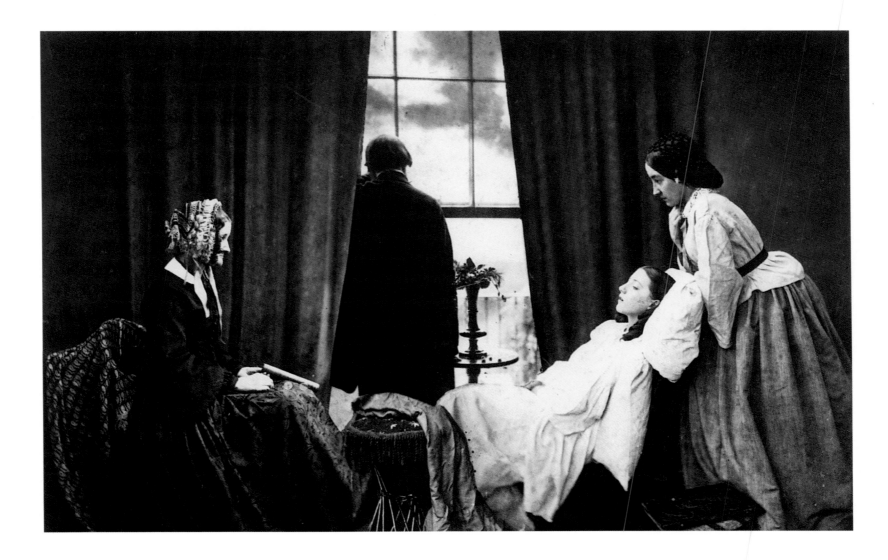

Influence of Art on Photography

Events like the French Revolution, which signified a victory for individual liberty, lent impetus to the growth of personal expression in the arts. The freethinking artist, whose uncompromising bohemian lifestyle annoyed the establishment, became the exemplar of radicalism.

In Victorian times, most artists and critics were seeking romantic beauty in art. Lovingly crafted artefacts became the antidotes to galloping industrialization with its soulless factories, human exploitation and machinemade products. Photographs were, however, made by machines; they too could be mass-produced, and commercial photographers were getting rich by making them. Photography got tarred with the brush of utilitarianism – acceptable for the artisan, but anathema to the 'real' artist. Many photographers reacted by imitating salon painting, and as a result produced sentimental and allegorical photographs that denied the intrinsic and unique advantages of the medium in favour of some dubious 'artistic' quality. As a consequence, there have been few photographic heroes in most books on the history of art, despite the undoubted power and influence of the medium.

But should photographers worry whether they are elevated into the pantheon of great artists? As one respected late twentieth-century artist and teacher (Lawrence Gowing) remarked: 'Photography is more than Art'. After all, painting can never have that descriptive authenticity inherent in photography. A photograph does reveal something other than aesthetic beauty – the photographer re-presents the external world, however internal his or her preoccupations.

Although photographs, like paintings, can be described as 'made' rather than 'taken', the method is very different. A painter constructs a picture section by section and layer by layer, whereas a photographer normally searches for a readymade scene. The sensuous attraction of coloured oil paints and the comfort of a womb-like studio can be

'The sensuous attraction of coloured oil paints and the comfort of a womb-like studio can be seductive, especially as the end product is always called Fine Art...'

seductive, especially as the end product is always called Fine Art, which has a long and mostly honourable history. On cold winter days, the search for an elusive photographic image that will interest, illuminate or even excite can be frustrating, confusing and uncomfortable by comparison.

Both mediums are affected, however, by the norms of acceptability set by art dealers, critics, editors, graphic designers and so on. The degree to which you are affected by these external influences is up to you.

But do not worry if you feel you have been (obviously) influenced by what is 'in' at the moment – everybody is. Use the experience as a springboard – a point of departure – for more individualistic efforts. You may, however, reject the 'art for art's sake' notion, and prefer to work in the 'real' world inhabited by 'ordinary' people to

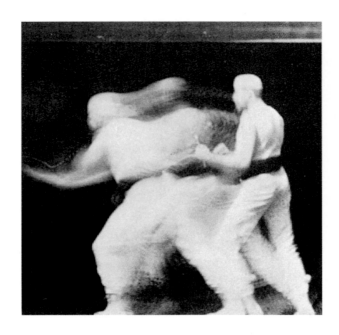

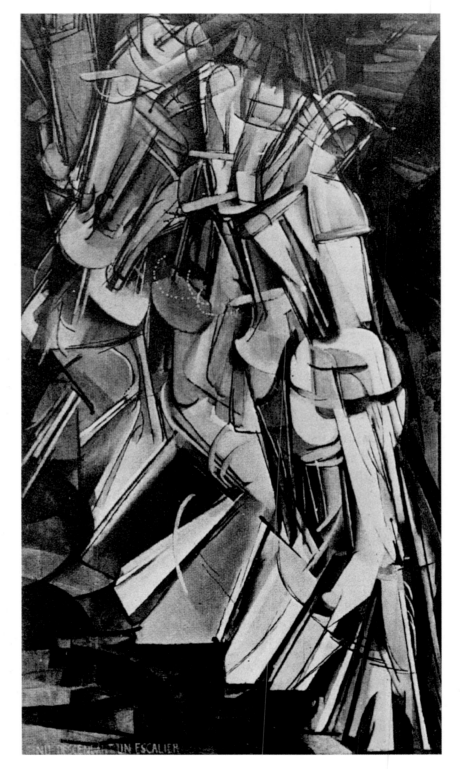

Above and Right Blurred nineteenth-century photographs influenced the Impressionist painters, and later the continuous-action images made by **ETIENNE JULES MAREY** (and Eadweard Muybridge) not only heralded the invention of cinematography but also greatly affected the post-Impressionists and the Futurists. The experimental genius **MARCEL DUCHAMP** acknowledged the influence that Marey's photographs had on him, particularly in his painting *Nude Descending a Staircase No. 2*, 1912. *(Courtesy of Archive de Cinematheque Francaise; Philadelphia Museum of Art, the Louise and Walter Arensberg Collection)*

whom you can better relate. A great deal of art today can seem to have no functional use, and often appears elitist and esoteric in nature. Art, after all, cannot exist without man, but physically man can exist without art.

Evidence of the power of individual or collective creative expression may be hard to find in the everyday world, but its influence is pervasive – and often feared by those in authority. It can be no coincidence that the freethinking artist is one of the first to be locked away by dictators and totalitarian states.

Photographers could be more effective, some say, if they were to stop trying to seek respectability and status in the art world. Their energies should be directed towards attempting to make sense of the world, and to use the medium to improve society.

PERSONAL EXPRESSION

Personal expression, whether in words or pictures, can often appear to be too self-reflective and subjective, and consequently communication with other people may prove difficult. People tend to dislike or fear what they cannot understand, so antipathy usually results if a piece of work is inscrutable. But you should try to find out why you do not like something before condemning it out of hand. Closely examine the work and try to discern the maker's intention. You will probably learn something, and although you may still not like the work, at least you may know why. Blind prejudice can be much more dangerous than any artistic movement, as history has proved. Remember: it is by exploring new and exciting possibilities that you develop your own creative and intellectual capabilities.

Links with Literature

The history of photography's discovery and early development make the rivalry between the medium and painting understandable, but is photography closer to literature than to painting? Words describe things, as do photographs. This is obvious in reference to objects in front of the camera/observer, but it can also be more problematic when the photographer wants to express, rather than show, something. A metaphor consisting of words can conjure up a visual image, and a photographic image can also operate as a visual metaphor.

A photograph of a solitary cloud could evoke a similar response as Wordsworth's famous line 'I wandered lonely as a cloud' if the photographer conveyed that interpretation skilfully. On the other hand, a picture of a cloud that also shows, for instance, part of a football game, is unlikely to convey the same metaphoric message. Words are available to us all in the same way that things around us are available to be photographed. Once we have learned the basics of visual grammar we can use the results to communicate and express whatever we want to.

Narrative Flow

Whether the subject is a person, an event or a place, a photo essay (see also *Documentary*, chapter 5, page 80) attempts to convey a sense of narrative through its layout, the interrelation of the pictures and the use of captions. But the viewer still has to impose the flow of a storyline on the string of

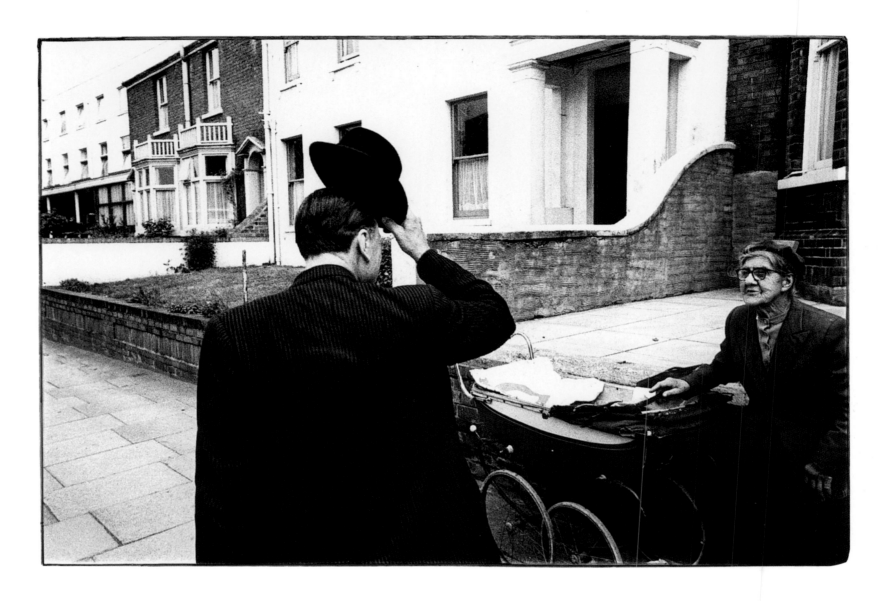

Above and Facing Page To give a sense of cinematic narrative with still photographs is asking a great deal of the medium, but this can sometimes be achieved in an 'action/reaction' sequence. Here, politician Enoch Powell doffs his hat to a woman supporter, who, in the second picture, eagerly gives her reaction to the gesture to an interested passer-by. **PAUL HILL**

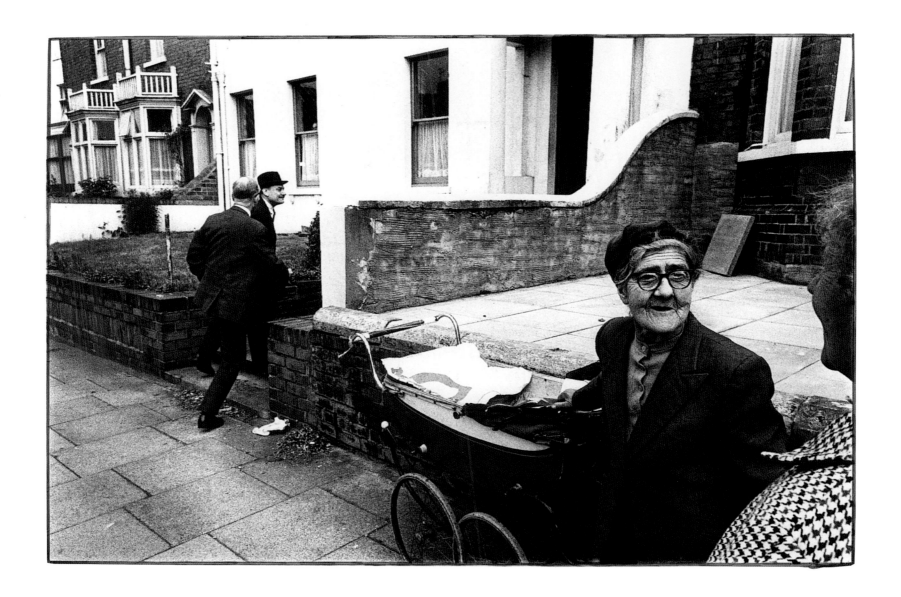

individual images presented. As a consequence, the successful communication of the story is as much a tribute to the perception and imagination of the viewer as to the skill of the photographer.

The Moving Image

It might have seemed strange to compare photography with literature, but it could be considered equally odd to compare photography with film or television. Just because their images are produced by the action of light on sensitive material via a camera does not mean that film making and video are similar disciplines to still photography. Moving pictures give a sense of chronological continuity – a narrative – that still photography tries to emulate through the photo essay and the sequence, but the illusion of reality is much more successfully achieved in films and television than in stills. Movies capture a semblance of the continuum in which we live, despite the fact that the results are just as artificial as those produced by still photography. Blurred photographs may give the impression of movement, but they will always appear to be contriving an effect in comparison with the real sense of movement conveyed in film and television.

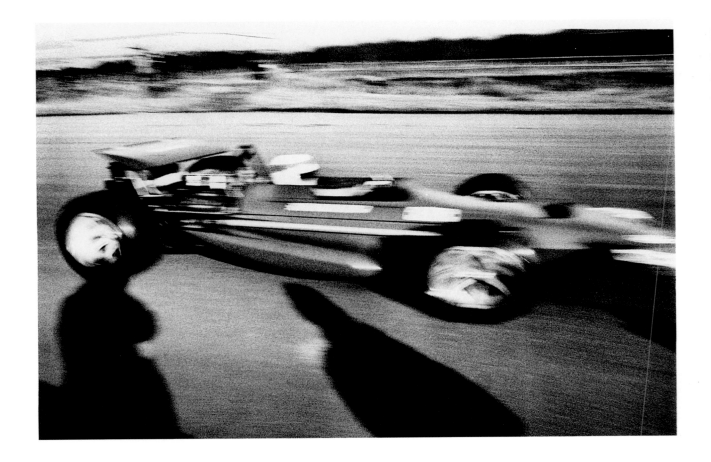

Left When you pan the camera (in this case with a wideangle lens), you can create some strange effects which give the picture the sort of visual impact that attracts attention. Here, the lens appears to be stretching the racing car, and this enhances the impression of speed created by the panning. The shadows on the track add an air of unreality to the situation.
PAUL HILL

Mixed Media

Photography, film and television may frequently overlap, but they are nonetheless very different in their application. The choice of medium should be governed by its appropriateness in the context of your ideas. If film, television or sound can communicate your ideas better than still photography, use them. Stretch photography as far as you want, but do not expect it to do things that it is incapable of. While you should not be afraid to use a mixture of media (e.g. collage, photo-sculpture and hand colouring) to produce the effect you want, remember that if you are too capricious and gimmicky in your use of media, the result may appear superficial. Your intention can be destroyed by flashy techniques that have little substance or lasting power.

Visual Impact

The weird images produced by ultra-wideangle and zoom lenses or computer manipulation can give that eyecatching impact so evident in professional photography today. Visual impact is used like a magnet to attract the viewer's attention to the advertiser's product or, in magazine photojournalism, to the writer's story. Advertising sells 'dreams' as much as journalism uses 'angles', and the camera is a powerful weapon in both of their arsenals.

The technical, creative and professional acumen employed by advertising, newspaper and magazine photographers can be awe-inspiring, but it is necessary to decide if the work demonstrates more than a consummate facility with the medium or the

'...it is necessary to decide if the work demonstrates more than a consummate facility with the medium or the photographic industry's latest technological gimmick.'

photographic industry's latest technological gimmick. The 'dream-sellers' of advertising and the 'propagandists' of journalism may not always present the truth as we understand it, but nevertheless their work gives a great many useful insights into how commerce and society works. A photograph often distorts reality and can be exploited by those who wish to manipulate their audience. It may be a cynical point of view, but both advertising and journalistic photography reflect the old newspaperman's tongue-in-cheek maxim: 'Never let facts interfere with a good story.'

While there are as many ethical and moral questions to be considered in photography as there are in life, do not let these problems have an unnecessarily inhibiting effect. The doubts and fears you may have will rarely be resolved by theory, but they may be resolved by the practice of photography. As long as your actions do not give rise to unnecessary suffering or offence, 'shoot first and ask questions later' may be the best way to learn photography.

Chapter Four: **HOW PHOTOGRAPHY IS USED**

Man Ray
Photographer and painter (in an exhibition catalogue)

Where Do We Put Photographs?

Images, like sounds, have no intrinsic significance.
It is the interpretation put on them by the maker
and then by the viewer that gives them meaning.

There are few rules to aid the communication
between the photographer and the viewing public,
just guidelines. People tend to relate to content
(subject matter they can recognize) first, and to
composition (or 'form') second. We usually see
what we want to see, and not always what is
actually there. This has a great deal to do with our
cultural and educational background, and also
with the context in which the work is seen (i.e.
galleries, portfolios, archives, books, magazines,
newspapers, posters or websites). For example,
your reaction to a 'fine' print, seen in an art gallery,

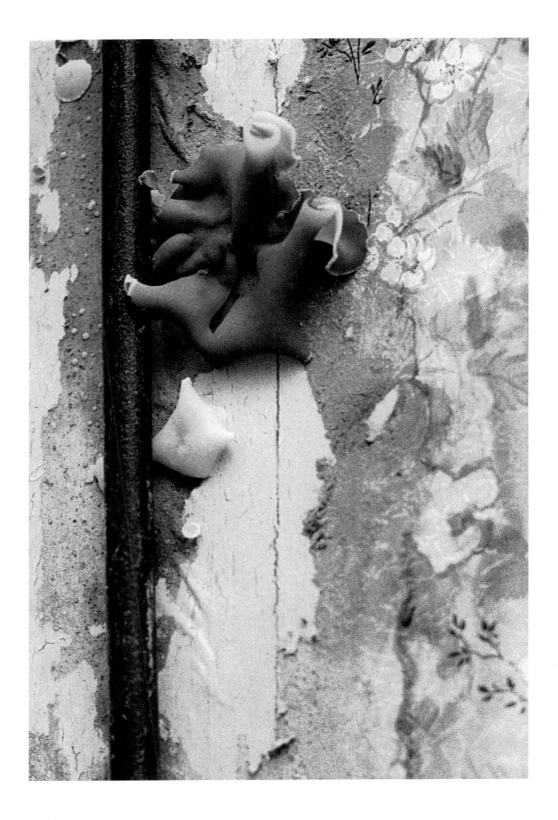

Right The context in which photographs are seen and used
is often a fundamental factor in the understanding of them.
A 'fine' print of this photograph of fungus and peeling wallpaper
would be similar to many such abstract still lifes that are seen
in photographic exhibitions. But this image was not taken to be
hung on a gallery wall; it was used to prove that damp was
badly affecting a housing estate. **PHILIP WOLMUTH**
(North Paddington Community Darkroom)

of fungus growing on peeling wallpaper would be different from your reaction to a reproduction of the same print illustrating an article on damp conditions in housing estates.

This difference in interpretation should not be confused with deception. Integrity cannot be a characteristic of photography, but it can be a quality possessed by the photographer. The fungus and the peeling wallpaper are neutral; the way you photograph them and the way you present the photograph is not. Photographers do not exist in a vacuum. Meaning can come from context as well as from content and form.

Captions and Titles

You should be very aware of the implications of your actions when you put your work into the public domain. Photographs do not speak for themselves. You might be quite happy for the viewer to make up his or her own mind, but if you want them to get your point, you must give a few signposts. This can be achieved through the use of captions and titles, and also perhaps by using complementary texts or sound recordings.

Captions are usually written to help explain what is going on in the picture and are often quite lengthy. The personalities, the location, the event, the date and, perhaps, the photographer are identified. As it is used in newspapers and magazines, as well as in displays of documentary photography, this type of captioning is probably most familiar to us.

Below The American photographer Gary Winogrand once said: 'There is nothing more mysterious than a fact clearly stated.' This work – a large gallery piece in reality – proves this statement. The text, which is an integral part of this work by artist **ROGER PALMER**, states a fact, but the photograph apparently shows something else – a minimal landscape with not a trace of a river in sight. His photograph is geographically correct, but it can never confirm the text. Reality and truth reside in the mind, not on pieces of paper.

A SOURCE OF THREE INDUSTRIAL RIVERS

THE MAN WHO INVENTED HIMSELF

Everything that he experienced in his lifetime were his inventions. He invented the moon and the stars and all things visible and invisible. At this moment he is inventing me writing this and you reading this. Yes you too are his invention. Yet if you told him this, he

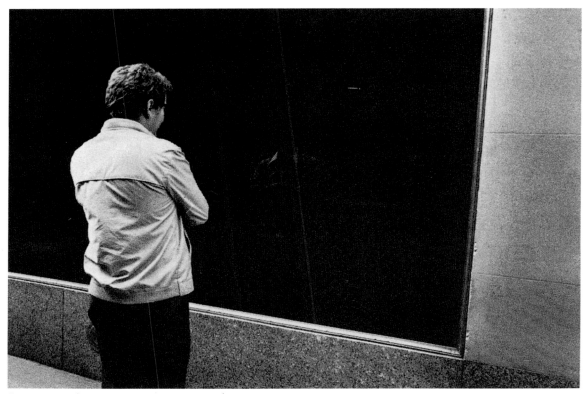

would deny it. Even though all things that he tought were possible became possible; and all things that he thought were impossible became impossible. He would even invent his own death. And he would never know that he had invented it all.

Titles are usually succinct and often allude to the emotional or conceptual source the photographer has used for the pictures. Whether witty or serious, obvious or obscure, they can be either subservient to the image – interesting appendages rather than necessities – or an essential component.

Very often, photographers include a written statement with the pictures explaining their intentions and working methods. This can also contain biographical details and/or an explanation as to how the photographer arrived at the ideas reflected in the work. Sometimes a poem or a piece of prose by someone else will complement the work more successfully.

Galleries

Photographers who show their work in galleries for the first time often find it difficult to adjust to the type of space afforded them. Before you can come to terms with galleries, you will have to consider the appropriateness of the environment, size of prints, frames and so on, and the relevance of your photographs to gallery presentation. Some galleries are similar to mausoleums and others are like noisy boutiques, but many are in-between: serious, without being forbiddingly solemn. You will have to choose the sort of gallery that best suits your work.

The kind of gallery you are probably most familiar with is the specialist photographic gallery. Many of these are non-profit-making establishments heavily supported by public funds. Your work in the context of these galleries will be considered with that of other contemporary photographers. It would be advisable to choose the gallery whose philosophy and policy fits in best with your own interests. Some gallery directors have very catholic tastes, while others are interested in one particular sort of photography almost to the exclusion of everything else. Their exhibition policies usually speak for themselves.

Many galleries that normally exhibit paintings, prints and sculptures also show photographs from time to time. In such settings, your work will be displayed with the other visual arts and will tend to be compared with them in terms of presence and conceptual rigour. These exhibition spaces may be in a municipal museum, art gallery or art centre, or they may be owned by an art dealer who relies on selling work to make a living. The latter type of gallery attempts to attract collectors and often caters for market requirements.

Exhibition outlets are, however, not confined to those listed above. You can show your photographs

in retail stores, leisure centres, schools and hospitals, or on the internet; in fact, anywhere that provides space and the opportunity to display pictures. Where you show should depend on your preferences and the way you want your work to be seen.

Hanging Prints

When investigating exhibition outlets you should consider a number of aspects. Strong, even illumination is necessary for most photographs. The colour and dimensions of the walls are also important; small prints will get 'lost' on a large, high wall because they a likely to need an intimate atmosphere. The length and continuity of the walls will affect the sequential development of your prints and how they are hung. A final consideration is publicity – there is little point in working hard to produce an exhibition that nobody knows about!

This type of research pays dividends because it indicates what size your prints should be and how you should mount them (for example, the type of mounting card and the dimensions of the window-matts that surround the prints). It will also indicate whether you should frame your prints (and, if you do, the sort of frame, the type of glass and fixings, and so on), or block mount them, as well as the number of prints to be shown. Try to avoid using every exhibition as a retrospective of your 'best' photographs; show the prints that cohere most effectively. You must also decide which print(s) to use for the invitation and/or poster for the show, and the choice should reflect the theme or style of the exhibition as well as creating a striking impact.

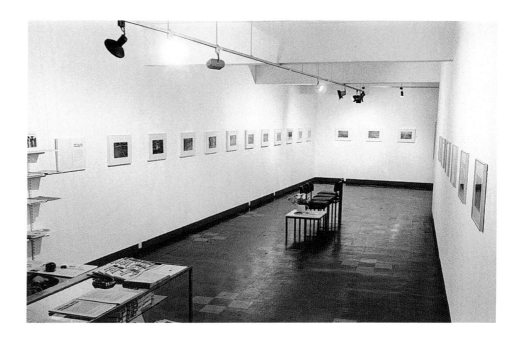

Above/Below Galleries come in all shapes and sizes, and in different colour schemes, but they give effective opportunities to present work to the public. The geography of the space can affect the way the work looks, so every detail, including framing, wall colour, lighting and furniture, has to be borne in mind when considering the gallery venues for your photographs. **PAUL HILL**

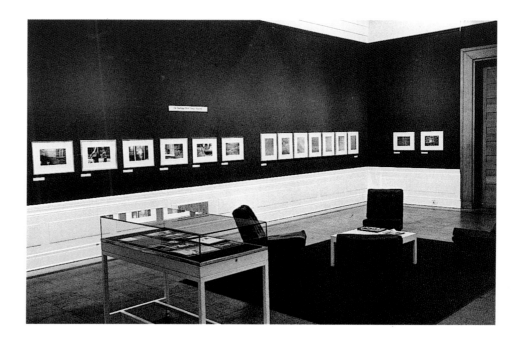

Portfolios

Most of the time, your work will be in portfolio form, but you should not confuse a box or folder of loose, dog-eared prints with a portfolio. A portfolio should be like a small portable exhibition: cleanly mounted and carefully boxed. It is probably easiest to contemplate a photograph by holding a simply mounted print in your hands. You can then explore the image in its 'raw' state, without glass, a frame or the distractions of a public place. Portfolios of prints presented in this way can be experienced in the comfort of your home or in the relative tranquillity of a museum archive or library.

If it is acquired by an archive, a portfolio should be processed for permanence, which means that the prints have to be cleansed of all potentially destructive chemicals and usually mounted on acid-free boards using approved adhesives. This sort of conservation is not preciousness; it is just good photographic practice, which should mirror the care and concern of the photographer for the medium and their work.

Publishing and Reproduction

Galleries and portfolios are the most effective ways for the public to see your *original* prints, but they are obviously not the only outlets for your work. Fortunately, photographs can be reproduced in books, magazines, newspapers and posters, as well as electronically.

In the same way that it is flattering to be asked to exhibit in a gallery, it is gratifying to see your photographs in print, especially if your name is by the picture. These reactions are natural and should not be despised, but nor should you accept an invitation to exhibit or be published out of conceit alone. Hopefully you have something to say in your pictures, or in the case of a commission be able to do the job successfully!

However, the pitfalls of publishing work in reproduced form are legion. One of the major reasons for advocating caution is that the reproduction process will be undertaken and controlled by others. This means that you are almost always at the mercy of editors, designers and printers, and they are unlikely to care as much about your pictures as you do. On many occasions there is excellent cooperation and the results bear this out, but it is often the photographs that suffer. In the same way that a photograph is a representation of actuality, so a reproduced photograph is only a copy of the original photographic print – and often an inferior one if great care is not taken.

Books

Facsimile reproduction should be attempted in book and catalogue publishing, but requires a high level of reprographic skill and can be expensive. Publishers of photographic monographs usually make every effort to achieve facsimile reproduction and sometimes the reproductions even improve on the originals! Although good reproduction can be crucial to the success of a book of photographs, the layout sequence of the images is equally important.

As monographs concentrate on the work of one photographer, it is common to put only one image on a page so that the reader can see each photograph as an individual piece, almost as if it were in a portfolio. The selection of photographs that are to be on facing or alternate pages, the choice of text and typography, the exact placement of the image on each page and, most importantly, the format and size of book, are usually decided by the designer in consultation with the photographer. If the photographer is only illustrating a book he or

MELIN COPA'R MYNYDD

I walk small vertebrae
 of stone,
tread a ridge of spoil-tips,
 the sun red
 in my hand.

The mill stands rotten-toothed
wind cracked stone.

My shadow leaps
 into blue and pink,
 it stands
 a hole in light.

I am between yellow and sky,
in the sea's ring
in the call of ravens.

Above Several photographers produce books in collaboration with writers. Photographs and poems can work together very well if they complement each other. This example is from *Mynydd Parys* (Seren Books, Bridgend, 1990) by poet **GWYN PARRY** and photographer **STEVE MAKIN**.

meteorite landings

ME HOLDING THE CANOE I WAS CONCEIVED IN. IT'S FUNNY TO THINK THAT THE OZONE LAYER WAS UNPENETRATED AT THE TIME OF MY CONCEPTION (OR NOBODY TOLD US IF IT WAS) – NOW "LOOK AT ME, I LOOK LIKE I AM HAVING SEX WITH THE HOLE IN THE OZONE LAYER." THIS PHOTOGRAPH WAS TAKEN BY MY EIGHTY TWO YEAR OLD NEIGHBOUR MRS SHARPE, WHO HAD NEVER TAKEN A PHOTOGRAPH BEFORE IN HER LIFE – INDEED THIS WAS HER FIRST AND LAST PHOTOGRAPH.

ONE CHRISTMAS EVE MRS SHARPE SWEPT UP THE LARGEST METEORITE WHICH HAS EVER FALLEN IN THE BRITISH ISLES. IT FELL AT 4.12 PM ON DEC 24TH 1965 AND LANDED ON THE ROAD RIGHT OUTSIDE OUR HOUSE IN BARWELL, LEICESTERSHIRE, WHILST I WAS ONE AND MISSING MY MOUTH WITH FOOD, BUT MRS SHARPE WAS OUT LIKE A SHOT, SWEPT IT UP AND PUT IT IN HER DUSTBIN, THINKING IT WAS LUMPS OF COAL WHICH HAD FALLEN OFF THE BACK OF A PASSING COAL LORRY. IF YOU DON'T BELIEVE ME LOOK IN THE GUINNESS BOOK OF RECORDS.

IMAGINE BEING CONCEIVED IN A CANOE, AND THEN, JUST OVER A YEAR LATER, KILLED BY A METEORITE. (THE SURVIVING LUMPS OF METEORITE ARE IN THE NATURAL HISTORY MUSEUM).

AS FOR THE LATE MRS SHARPE, SHE IS THE ONLY PERSON I'VE MET WHO HAD HANDLED A METEORITE BUT NEVER TAKEN A PHOTOGRAPH.

Above Self-publishing can be a way of showing work to a wider audience. With *Mrs Sharpe's Cracks* (Artless Publications, Leicester, 1996), **GREG LUCAS** also wanted the monograph to be a creative work rather than a catalogue of his 'greatest hits'. By challengingly mixing photographs with text and collaborating with good designers (Christopher Large and Marc Cram) he has achieved a unique publication that a commercial publisher would not have undertaken because it is not 'safe' and could only justify an uneconomically small print run.

she will have very little say in the design and choice of pictures. In fact, the photographs may be subservient to the text and the design.

The Internet and Electronic Publishing

Computers have also given the photographer the chance to reach widespread and diverse audiences. The ability to place photographically produced images onto electronic circuits enables photographs to be transmitted worldwide via the global communications network. Digital cameras can transmit images directly to this network, and photographic prints, negatives and transparencies can be scanned into a computer in order to take the same pathway. Even if you are pursuing a conventional image-production route, you cannot ignore this exciting possibility to put your work into the public domain at little cost. Photographs are also published electronically on CDs, which are another excellent way of storing and distributing images for viewing.

Computer software technology has now created virtual-reality galleries where the viewer can have the illusion of exploring real museums and galleries. These interactive facilities help the user to call up the images they want, and give 'exhibitors' the opportunity to expose their work to a worldwide audience via the internet. This is also an invaluable way to access historical and contemporary images and information.

Of course, images that have become electronic entities do not have conventional physical status. You should also be aware that work appearing on the internet could be appropriated by others and used in ways that you might not approve of. The internet is a liberating system that is prone to anarchy and almost impossible to control centrally by any authority. This makes it subject to the usual problems that humans make for each other in all forms of publishing – and in life generally!

Commissions

If you undertake to provide photographic illustrations, establish how the pictures are going to be used and on what basis you are commissioned. The excitement of getting your work published may quickly turn to disappointment if you find that the pictures you strove so hard to make have been insensitively cropped or badly reproduced. Without proper stewardship, a potentially excellent showcase for your photography could turn out to be a disaster for your photographic career. It is a good idea to put the precise requirements, fees, expenses and other conditions into writing first, so that both parties know where they stand. Most responsible organizations have standard contracts. Another solution may be to engage the services of a respected literary or photographic agent.

'The excitement of getting your work published may quickly turn to disappointment if you find that the pictures you strove so hard to make have been insensitively cropped or badly reproduced.'

Magazines

The same problem could arise in dealing with magazines, but as periodicals come out regularly you will have a good opportunity to study the market before you enter into any arrangement with them. Always be suspicious of an editor who will not give you any idea of how your photographs will be laid out. This is particularly relevant to photographic magazines that rely on photographs for their raw material. Once they have committed themselves to publishing your work, they should treat it with respect. This includes ensuring that it is reproduced to the highest standard their printers are capable of. Having said that, it might be fair to add that the vast majority of publishers are not run by philanthropic organizations, and they can only afford to go as far as the economics allow.

Newspapers

What is news? A humorous definition you may have come across declares that news is 'When man bites dog, not when dog bites man.'

Dramatic events, celebrities and gossip are the important mainstays of most popular newspapers, while the more 'serious' ones set out to be organs of record and interpreters of important events. Unfortunately, a strong sense of caricature invariably results from popular journalism's treatment of most news items. Stories are also exaggerated, and issues frequently become very black and white. Newspaper photography is, of course, affected by the same ethos. For example, a photograph of a

prominent politician delivering a speech will rarely warrant publishing, but if he or she slips on a banana skin, it will be front-page news.

It could be argued that this kind of photograph reveals the human side of our political leaders, but it also demonstrates that trivial incidents often make the most popular pictures. Unfortunately, the search for the bizarre by newspapers often reflects this trivial attitude, and the results can seem laboured and/or predictable.

Newspaper photographers are always on the lookout for an exclusive. Being in the right place at the right time – luck, in other words – is more likely to produce a memorable 'scoop' than the visual talent of the photographer. Many famous 'scoop' pictures have been taken by local newspaper and agency photographers who were rarely heard of again. The best news photographers gain their reputation by their consistency, reliability and perseverance – commendable qualities in any profession – and their tenacity is sometimes rewarded by that once-in-a-lifetime shot.

Photojournalism

Courage is frequently essential when photo-reporting in potentially explosive areas of the world, but the finest photojournalists exhibit a sensitivity and compassion that belies their almost rugged, ruthless image. Photographs of the pitiful casualties of war can be much more revealing in human terms than action pictures of shooting and bombing. They have a lasting universal quality that

can demonstrate man's frailty and innocence, and, at the same time, his capacity for senseless cruelty; the 'human condition' is thus reflected in actual life-and-death terms.

Although at any one time many parts of the world are being destroyed by war or riddled by corruption, most of us are not affected directly by headline dramas. Our involvement with them via the media is vicarious, even voyeuristic. Newspapers thrive on the fact that while the majority of their readers are passive, armchair observers, their reporters are 'out there' risking life and limb in order to bring us 'the real story'. And though the frequently hyperbolic and predictable nature of many photographs used in popular journalism may be embarrassing, a great deal of important and revealing work – which often discloses the flavour of our times better than long, in-depth magazine features – gets through.

Assignments

When covering events for newspapers (as opposed to magazines), it is important to remember that a picture editor tends to look for 'the picture that tells the story'. If this picture is dramatic as well, it will almost certainly be published. It is unlikely that

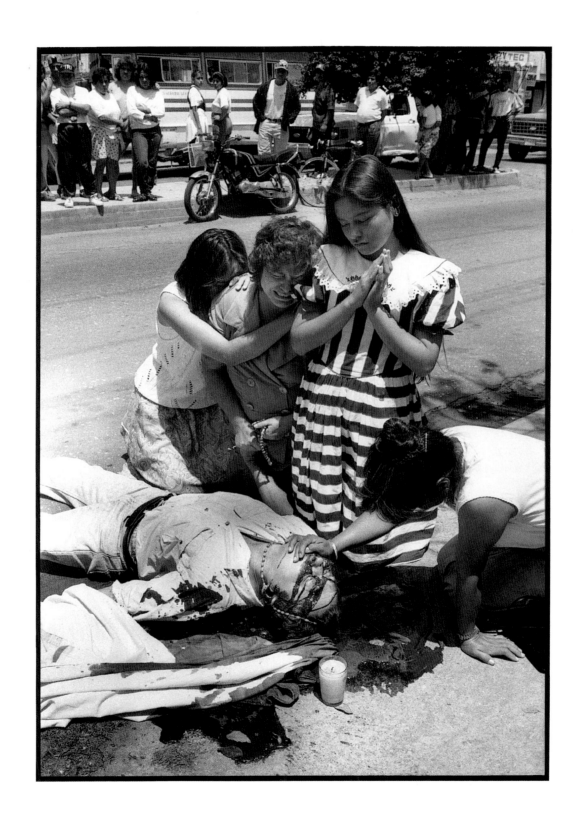

Above A 'scoop' may never come a photographer's way because it has more to do with luck and being in the right place at the right time than with talent. Whatever else **I. RUSSELL SORGI** may have done in his life, this picture *(Suicide 1942)* is what he will be remembered for. It was a once-in-a-lifetime moment that even the tragedy of the incident cannot diminish. *(Buffalo Courier)*

more than one photograph will be published per story, even though you may have a most interesting series of images.

On many occasions the possibilities for obtaining visually interesting photographs are limited, but it is important to keep searching for the telling picture; it is usually there somewhere. Lack of time may force you towards the hackneyed image, but do not despair. The wideangle portrait of managing-director-holding-firm's-product-in-front-of-factory, so loved by many photographers and picture editors, was thought quite avant-garde when it first appeared many years ago.

Constant repetition of the same type of assignment tests the most visually ingenious photographer, and exaggeratedly stylistic approaches are sometimes adopted in an effort to come up with something 'different'. As a result, photographic showstoppers can emerge that inevitably reveal style rather than 'truth'.

The predictability of a large percentage of newspaper assignments can be dispiriting, but to a photographer the continuous pressure and shortage of time, and the frequently diabolic newsprint reproduction, can be even more disheartening. Luckily, many newspapers today have good photographic reproduction and allow their photographers more freedom and time to exercise their visual talents.

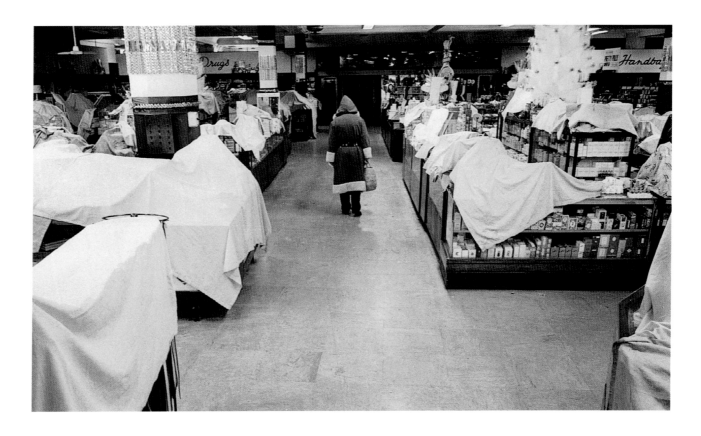

Right Some newspapers (normally the tabloids) seem to deal primarily with the more trivial items of news, but even 'serious' broadsheets such as *The Guardian* can take a light-hearted view of the world. They used this picture on their front page one Christmas to reflect the seasonal nature of short-term employment!
PAUL HILL

Posters and Photomurals

If a photograph is going to be used as a poster or mural, remember that your image – whether in original or reproduction – will be enlarged a much greater amount than normal. Consequently, there will be a loss of certain qualities visible in the smaller print. There will also be an increase in photographic 'grain', and while this may give a pleasing pointillist effect, posters usually depend on size for their impact and are therefore viewed from a distance at which increased grain size should not be noticeable. The physical constrictions of gallery frames, archival boxes, book pages, magazine layouts and newspaper reproduction do not apply to posters and photomurals. They are an excellent way to get photographs out into the street, for instance, so that more people have the opportunity of seeing your work.

Communicating with the public is always a problem, though. As the great expressionist painter Oscar Kokoschka rather cynically put it: 'I, and my public understand each other very well: they don't hear what I say, and I don't say what they'd like to hear.'

Above On numerous occasions, and with certain types of assignment, it is very easy to slip into one of the visual clichés a genre throws up. In this case, it is a multimillionaire businessman among the products that have made him rich.
PAUL HILL

Facing Page The predictability of many journalistic jobs, and the lack of time allowed to complete them, often produces a very stylised approach that sets a particular photographer apart from most of their contemporaries. **BRIAN GRIFFIN** is one such photographer. He specialized in portraits of people involved with the commercial and the show-business worlds. Here, he has taken a back view of the managing director of a book-publishing firm, which seems to make the book the subject of the picture, not the man. The arrow at his feet adds an interesting graphic dimension to the photograph.

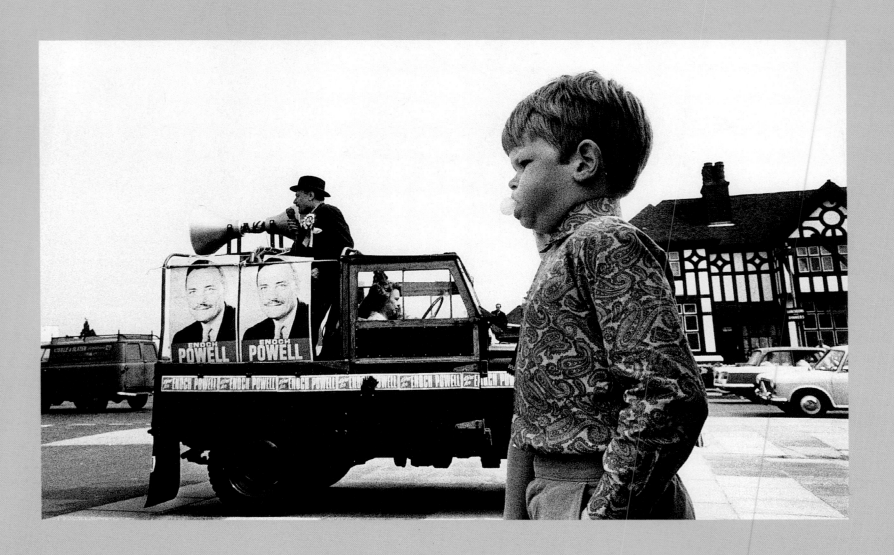

Facing Page and Below To interpret news events in terms of a single image is what newspaper photographers attempt to do in their photographs. MP Enoch Powell, whose political rhetoric concerning immigration and Allied matters was extremely controversial, dominated the 1970 British General Election. The boy's bubble gum seemed to mirror the hyperbole used in many of Powell's speeches, as well as appearing to symbolize the sort of reaction his critics were voicing at the time.

During the same period, pipe-smoking Harold Wilson was Prime Minister of Great Britain. He sought to project an avuncular, 'man-of-the-people' personality, but in reality he was prone to fits of insecurity and paranoia. His public persona was a smoke screen, although the photographer was totally unaware of this at the time. This image probably has greater currency now, with historians poring over the period, than it had at the time it was originally published in 1966.
PAUL HILL

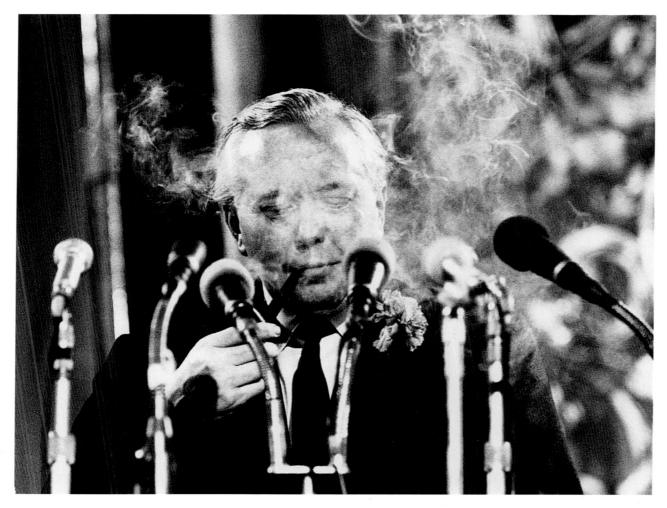

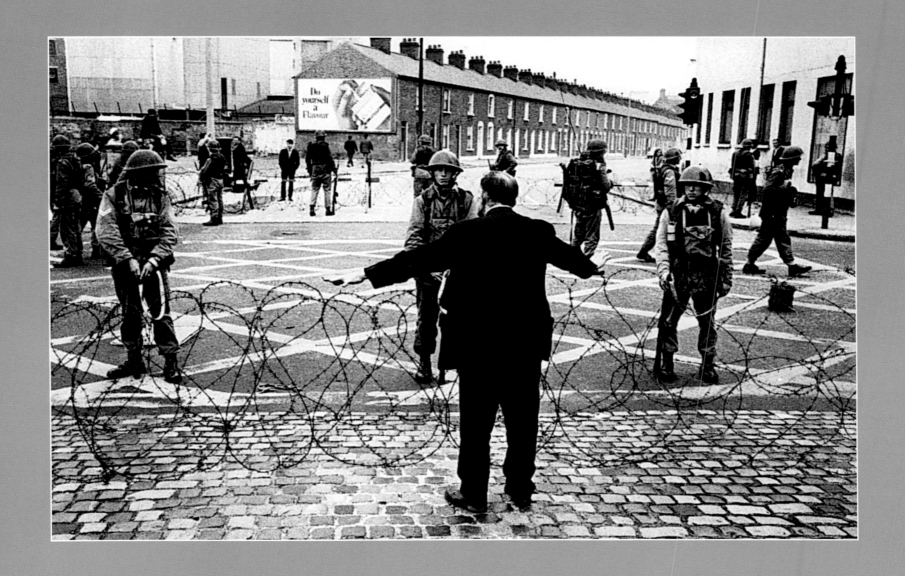

Chapter Five: **THE PHOTOGRAPHER AS WITNESS**

Making a Record

The vast majority of photographs are taken in order to make an image that appears to give an accurate representation of the thing photographed.

When you photograph your sister in front of the Eiffel Tower, you want your sister and the famous landmark to be identifiable. You would also like the photograph to confirm that you went to Paris accompanied by your sister, and to verify that you visited the Eiffel Tower together. Although photographs can be interpreted in many different ways, it would be obvious that a small print of this image in a photographic album shows that your intention was to provide yourself with a souvenir of France. It would also unequivocally prove that you had seen the Eiffel Tower. The photograph therefore becomes evidence.

> The photographer must prove that he has the passion and humanity with which to endow the machine.
>
> *Dorothea Lange*
> *Documentary photographer*

LEGAL EVIDENCE

Photographic evidence in a court of law has as much validity as verbal testimony, if not more. Photographs that show, for example, the position and extent of wounds or the relationship in a street of a stop sign and a crashed car, could conclusively prove someone innocent or guilty. The photograph seems honest and incorruptible because it is made by a machine and not, evidently, by man. The camera's apparent objectivity and the photograph's ability to describe and identify are among the medium's most valuable attributes, although the clever or deviant will always seek to manipulate this for their own ends. Photographs made by conventional processes are permanent pieces of visual evidence that confirm the physical existence of people, objects, places and events.

Snapshots

The snapshot is, of course, the most familiar sort of photography to us. With the 'idiot-proof' design of most modern cameras, anyone can successfully make a photograph. Although other photographs you see may influence you, the major objective when you start taking pictures is usually to get the subject in the middle of the viewfinder.

The snapshot never comes out as you think it will; it is either better or worse. As you become more knowledgeable, and photographically sophisticated,

'*There is great pleasure and fulfilment to be found in making unaffected souvenirs.*'

there is less uncertainty and, as a result, some of the magic goes. It is impossible to recapture those naive days, and naivety is one of the major ingredients of snapshots. They are pieces of unpretentious folk art that the professional cannot make. There is great pleasure and fulfilment to be found in making unaffected souvenirs.

Historians and anthropologists can learn a great deal from family snapshot albums, and we can as well. It is fascinating to see how our great-grandparents looked and dressed; it is pleasurable to relive through our 'snaps' those summer adventures when we were children; it is intriguing to work out how people and places have changed through the years. But those dusty pages may do more than jog your memory. Why are some members of your family rarely photographed? Why do some close relatives never stand next to

Right and Facing Page

The family album is a continuing testimony to the snapshot's position as the most relevant form of photography for most people. But underlying the apparent innocence and naivety of the genre, clues are to be found concerning human relationships and social history that, if seriously investigated, reveal valuable information.

(Samantha Lomas Collection)

each other? What is that little girl who poses with so much assurance doing now? Your investigations and detective work could help build up an interesting family history. It is no coincidence that sociologists and psychologists find snapshot albums an invaluable source of revealing information for their research and analysis. Albums do, of course, distort by omission, as we prefer to record happy, pleasant times, and never think of photographing sad events. It would be thought by most people obscene to take photographs at a funeral, for instance – but why not? We also rarely photograph our workplaces or domestic interiors.

Portraits

Photographs, of whatever type, are made by people for people, so it is understandable that the most common subject matter in photography should be human beings. The feature that identifies a person most conclusively is the face. Our physiognomy may not be as unique as our fingerprints, but it usually distinguishes us clearly from each other.

As we know, a picture of a face is called a portrait, but is a photograph of facial features a true portrait? Does a picture of your eyes, ears, nose, mouth and hair really depict you accurately? Alfred Stieglitz, the famous American photographer and gallery director, once said that a true portrait should be a series of photographs of a person taken at regular intervals 'between the cradle and the grave'.

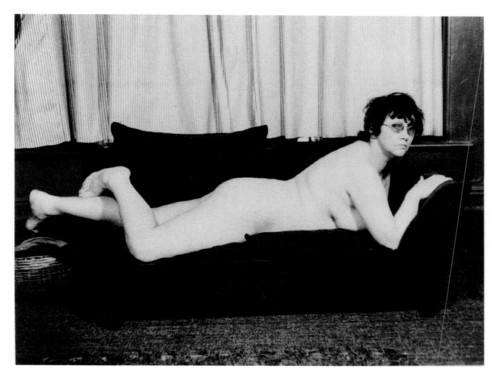

Left and Above
Me at 8¹⁄₂ months and
Me at 44 years 9 months.
These pictures of
photographer **JO SPENCE**
have a strong chronological
relationship, and combined
with other portraits taken
through the years –
reflecting changing
physical and emotional
states – could obviously
give an ironically true
picture of her life, primarily
because she had
constructed it herself.
(Photography Workshop)

When we make contact with each other we do so with our eyes. If anonymity is thought desirable (e.g. in photographs of prisoners in newspapers) the eyes are covered artificially on a photograph or, in reality, by wearing dark glasses or a mask. It seems that if you cannot make eye-to-eye contact with people in a photograph you cannot really identify them. But anonymity is usually the last thing that most people want in portraiture. We want them to be able to recognize the individual who has been photographed.

A photographic portrait is therefore often used by two very different sections of society: the police and the publicity business. Your face can be your fortune if you are an actor or model, but a circulated portrait can be quite the opposite if you are a criminal!

Portraiture was the first major commercial application of photography in the nineteenth century, and it was not long before most towns had a portrait photographer. Despite the phenomenal growth of amateur portraiture since then, there is still a great demand for professional portrait photographs. It may be vanity that motivates people to have images of themselves recorded by professionals, or perhaps it is an attempt to achieve some kind of immortality?

The professional attempts to capture the personality of his or her subject through the use of light, the angle of view and, above all, by 'freezing' a revealing expression that reflects the individual's character. But the way in which a photograph is taken may say more about the photographer's style than it does about the person being photographed.

Right and Below
The major identifying feature of a person is the eyes. When eye-to-eye contact is lost (as in these two photographs) people become anonymous.
JAMIE PARSLOW (Right),
DEBORAH BAKER (Below).

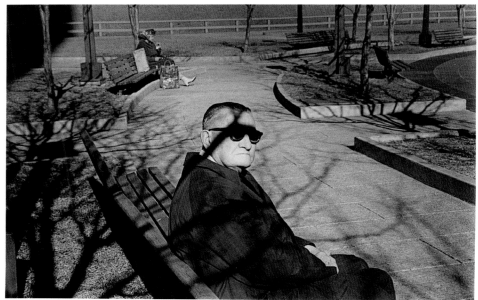

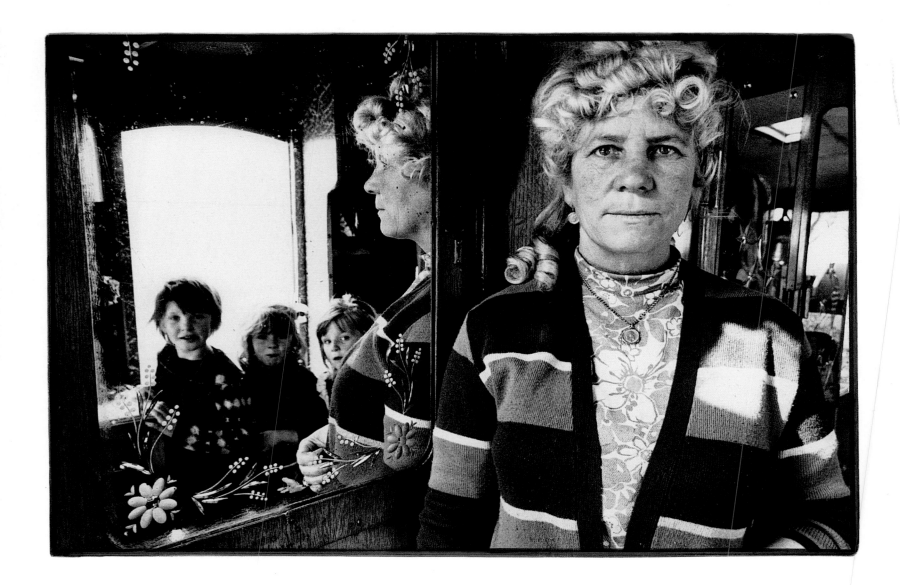

Above The disclosive nature of a posed portrait – as far as the subject is concerned – may be suspect and, in fact, say more about the photographer than the 'victim'. When you photograph people whose way of life and standards are different to your own, the responsibility to the subject is greater. The need to be 'fair' and non-exploitative is emphasized in these situations. The photographer lives in a different culture to the gypsy woman photographed here and will almost certainly have difficulty in making a 'true' portrait. **PAUL HILL**

The photographer may give an accurate impression of the subject, but the result could, on the other hand, be unintentionally defamatory. Like a hunter, the photographer frequently wants to 'capture' an expression or gesture. This can be done in a confrontational or a candid way. The portrait 'victim' can either be very conscious of the photographer or totally unaware of his or her presence. Consequently, the results will differ according to the approach.

A posed portrait can be just as revealing as a picture of a person taken 'on the wing', although the latter will appear more candid and natural. The former approach shows how people react to the camera – how they position themselves, what they wear and how they wish to be photographed. The pictures may disclose more about them despite the apparent artificiality of the situation. You also have a closer, more direct relationship with the person, which leads to a more responsible attitude towards them as a subject, rather than a 'victim'. If you prefer to conceal yourself from the subject, you may obtain a satisfactory 'slice of life', but is it a more truthful portrayal of a person than the posed picture?

Many people hate being photographed because it makes them feel self-conscious. In other words, it forces them to become acutely aware of their own appearance at both the time of posing and later when they see their photographic image.

The environmental portrait is one of the most convincing and informative forms of portraiture, as it attempts to relate the subject to their work or

'...the way in which a photograph is taken may say more about the photographer's style than about the person being photographed.'

home background. This type of portrait may be posed or candid, but it is only successful if the viewer appreciates the link between the subject and the environment. For example, a man in a room full of paintings could be an artist, a museum curator, or an electrician just about to mend the lights. If you want to convey the fact that the man is the artist, there are two methods you could adopt. You could either control things by posing the man in front of the paintings with a palette and brushes in his hand, or wait until the man makes a characteristic action, such as applying paint onto the canvas, and take the picture then. The latter approach demands patience, perception and quick reflexes. The man may only be painting for a brief time and you may be badly positioned so that the background is inappropriate. If photographed, this may create a juxtaposition that will confuse the viewer. Quick footwork, a change of angle, and you may have a successful environmental portrait, especially if the lighting is where you want it and the focusing, depth of field and exposure are correct. But with this approach the most important thing is to capture a moment that is the most

PORTRAITS WITHOUT PEOPLE

It may sound like a contradiction in terms, but it may not always be necessary for people actually to appear in portraits. A detailed photograph of the interior of a room may portray the personality of the occupants more accurately than any picture of their head and shoulders. After all, we usually gather around us the things we like or are interested in. A photograph of these items could be more 'you' than a photograph of your face.

effective combination of information, gesture and
composition. In other words, both content and
form (see box, above) should cohere for the picture
to be successful.

Documentary

It is obviously wrong to claim that photographs
never lie, but they can be used together with other
information to show the facts of a situation and
lead to a 'truthful' assessment of it. Photographers
committed to the in-depth documentary approach
do not look for the single picture that attempts to
'tell the story'. Their aim is to piece together visual
evidence in order to construct an honest document
that communicates the reality of a situation as the
photographer (or team of photographers) sees it.
This sort of work can never be totally objective, but
if the document reflects thorough knowledge and
involvement, it at least indicates a point of view
that has been acquired from more than transitory
personal experience. There are many sociological

and political applications for this type of
photography, although social conditions are the
most frequently addressed subject matter for the
committed documentarian.

The documentarian's finished work is usually seen
in an exhibition or publication, often with
accompanying written text (or tape recordings).
The text may contain the actual words of the people
photographed, or other participants connected
with the photographer's project. These are used to
complement the photographs and to ensure that
the audience is given every opportunity to
understand what is going on in the pictures. The
true documentarian does not aim for an esoteric
end product that only a few can understand;
communication with, and comprehension by, a
mass audience should be the aim with this type
of photography.

One of the best ways to reach a mass audience is
via newspapers, but they tend to deal with single
pictures and consequently they are usually not
interested in most documentary work unless it has

*'...communication with, and comprehension by, a mass audience
should be the aim with this type of photography.'*

a topical, 'newsworthy' angle. The largest mass
audience is the television-viewing public, and that
is why many documentary photographers move
into film and video. They also tend to stay there.

News magazines often have a large international
readership. As well as stories illustrated by single
pictures, they may publish picture stories and

Below The documentary approach to portraiture usually places the subject in an identifiable environment. In this case the subject is an Asian who works in an English iron foundry. The picture not only conveys his working conditions, but also highlights his isolation, even during rest periods. **PAUL HILL**

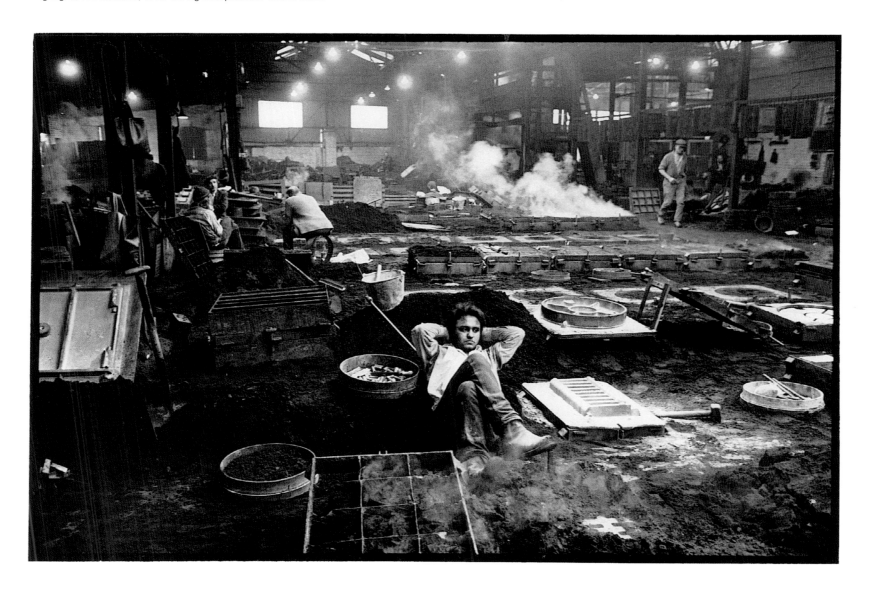

photo essays. *Picture stories* usually revolve around important news events like war, a state visit, a major weather disaster and so on. A team of photographers is dispatched to the location and they cover as many aspects of the story as they are able to. All the photographs are sent back as soon possible, often by electronic means, and the ones to be published are selected by a small team of editors and designers. One photographer may obtain the best pictures (he or she may have been in the 'best' position), but it is essentially a team effort.

A *photo essay*, on the other hand, is generally done by one person and is not usually about a news item. Narrative is important and normally each essay should have a beginning, middle and end, as those types of stories – in literature and photography – are always the easiest to understand and enjoy. This form of visual communication has very few language barriers and should, therefore, aim to be universally comprehensible. This makes the photo essay a classic and often poetic mode for transmitting information. The overall structure of the photo essay is very important. The images (like those conjured up in poems) made around one part of the story must be linked with those made around the next and carried through the whole essay. You obviously have to concentrate on one part of the story at a time, but you should never lose sight of the narrative concept of the project.

There are some basic points worth remembering when considering the making of a photo essay. An 'establishing' picture of the location gives the reader a general view of the physical area involved. If people are included – and they usually are the

'Narrative is important and normally each [photo] essay should have a beginning, middle and end...'

Pages 83–7

In-depth documentary photography attempts to 'get under the skin' of a place, a group, an event, or a social problem. The photographer has to spend a long time piecing together visual evidence in order to get something approaching a true document that fairly represents the subject matter. **KATE BELLIS** spent several years photographing the hill farmers of Derbyshire to show, in particular, how they have coped with the momentous changes to British farming in recent times. She also interviewed her subjects in order to get a fuller picture of their lives, but it is the telling and eloquent quality of her photographs, culminating in the exhibition and book *On the Edge* (Rural Media Company, 2001), that resonates most.

main ingredient in photo essays – try to show the relationships between them. If there is a central character, attempt to give them an identity that the viewer can comprehend. You know your subject's occupation, but the reader does not unless you are able to transmit this fact visually through your pictures. Similarly, when photographing an event it, too, should be given an identity. The action at the event will often be self-explanatory if it is a familiar or common occurrence, but if it is outside the reader's personal knowledge or culture then it may be baffling. A photo essay of such a situation should attempt to explain what is happening. Remember that the reader is not there with you.

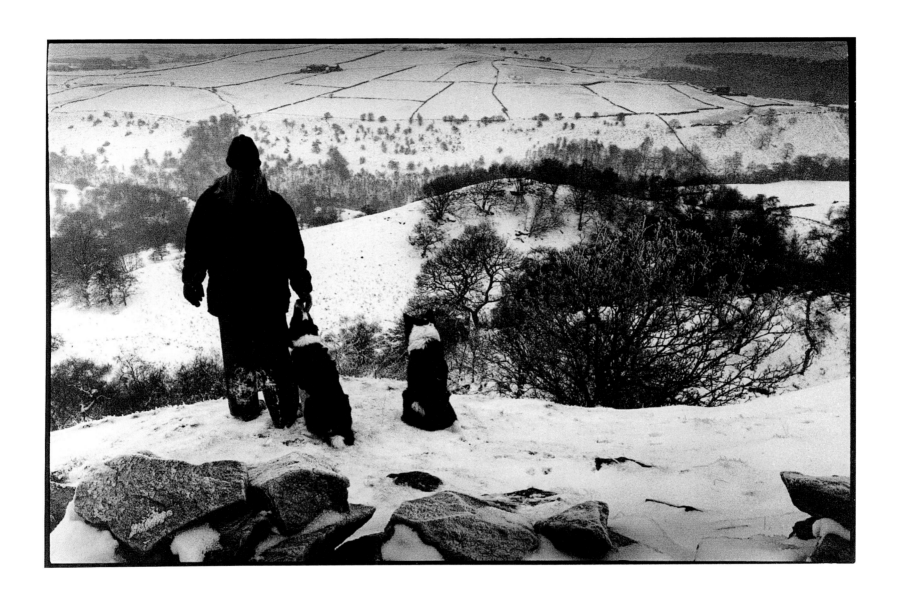

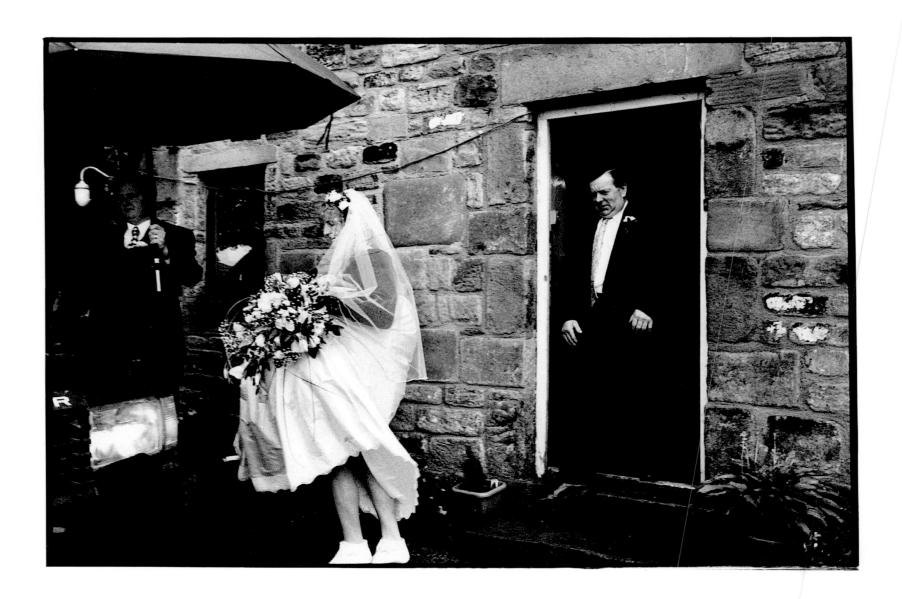

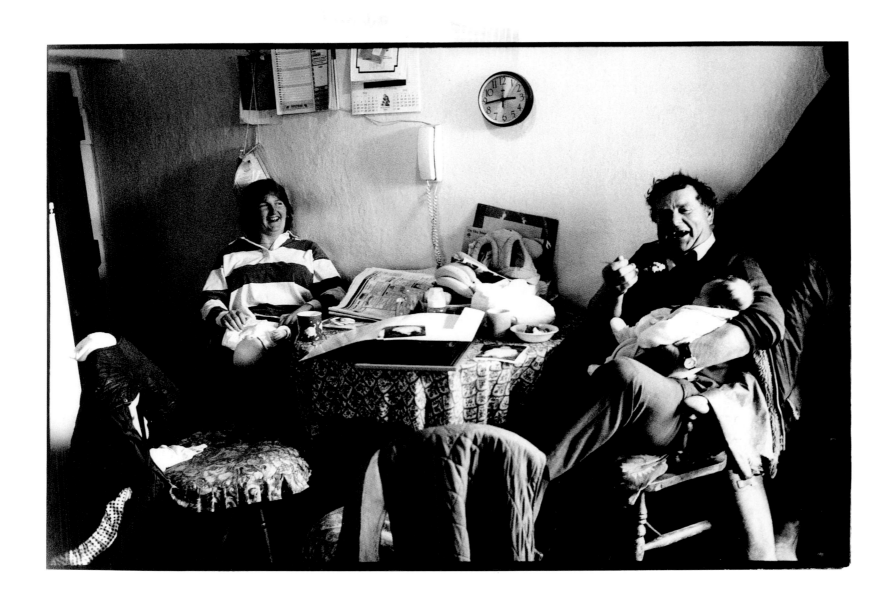

Pages 88–95

The pictures in this photo essay have to combine together to form a storyline that is comprehensible to the reader. The subject is the annual Appleby Gypsy Fair in Cumbria, and the narrative strategy is as follows:

People arrive at the fair **(a)**, giving the reader an idea of location. The horses are washed **(b)**, rinsed **(c)** and dried out **(d)**, before being tied up for potential buyers to examine them **(e)**. Then the sale is confirmed with a slap of the hands **(f)**, before a relaxing and celebratory drink **(g)**, followed by a nap **(h)**.

This may seem to be a simplistic scenario that has no central character (except the horse, perhaps), but nonetheless assumes there is one by the 'construction' of a narrative flow. Enhanced by the captions, this is the best a photographer can do to relay the essence of the diverse activities going on before him or her on that day. **PAUL HILL**

(a)

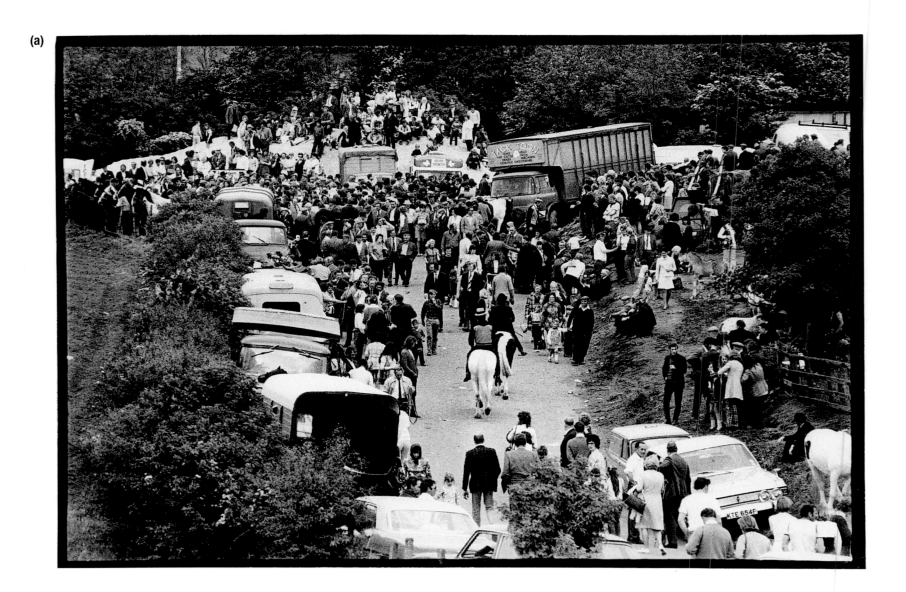

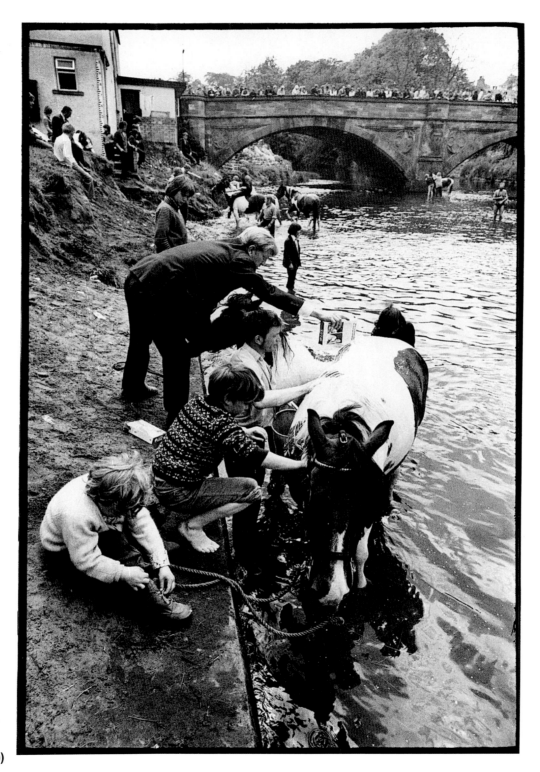

(b)

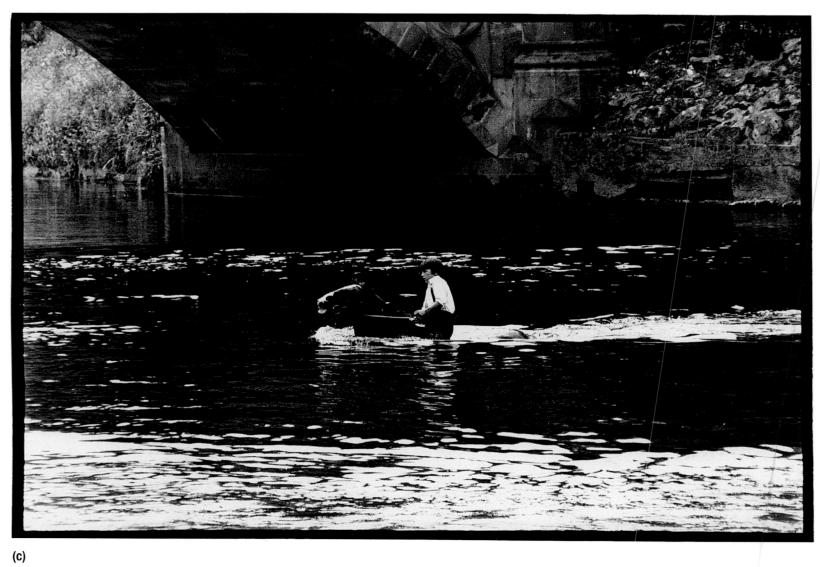

(c)

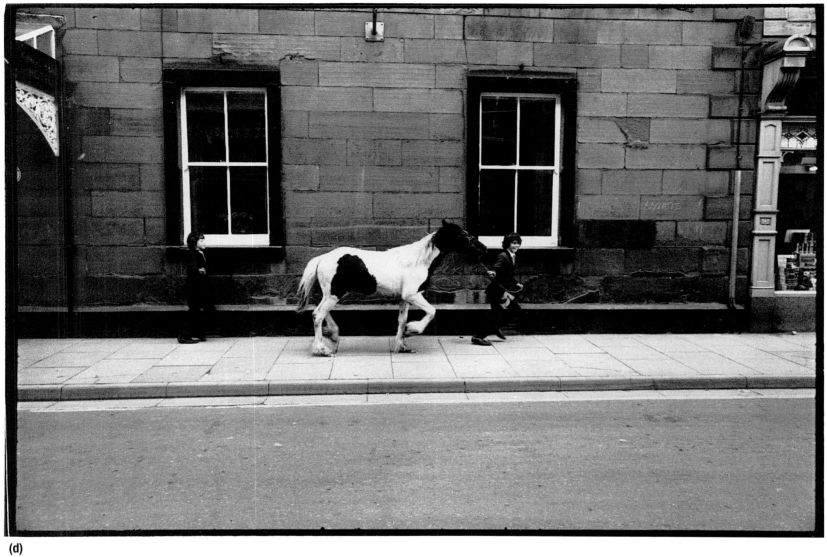

(d)

(e)

(f)

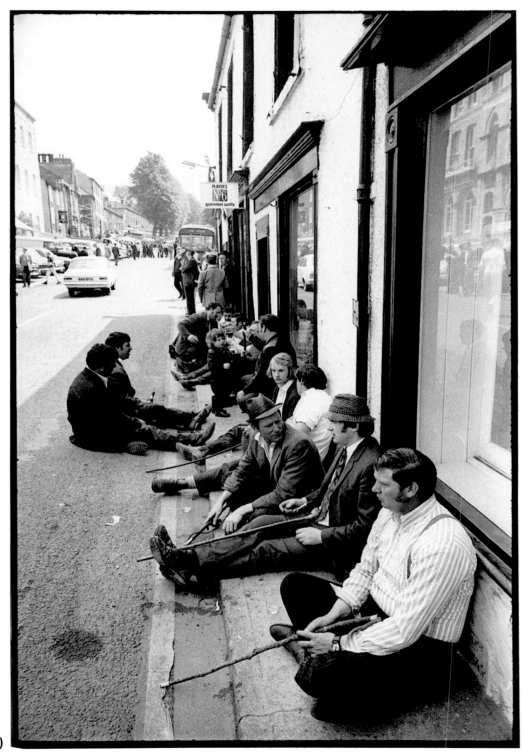

(g)

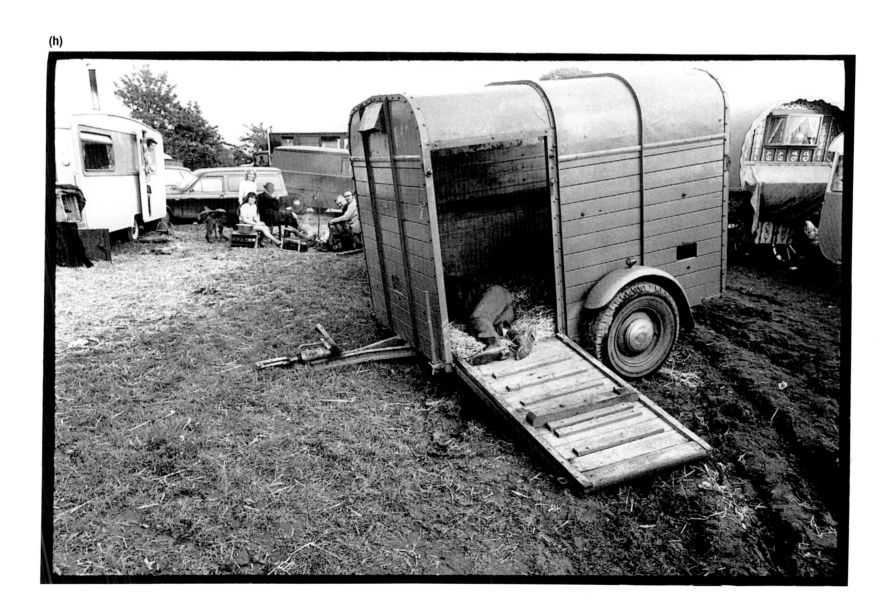

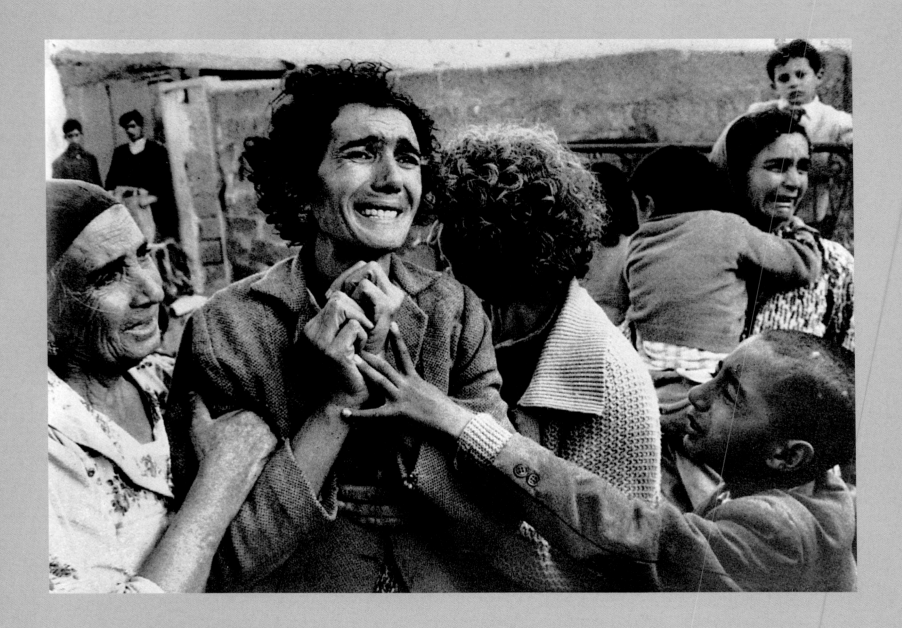

Events

Momentous national and international events can be even harder to narrate visually. How can a photographer adequately show in a series of pictures, let alone a single image, the scale of a violent conflagration or the enormity of a disaster? All that you can probably do is indicate the cost in terms of human suffering. This can often be seen most vividly in the expressions on people's faces. It can also be hinted at through telling or even ironic juxtaposition of incongruous or contrasting subjects. Action pictures on their own rarely convey the horror of war, as most military conflicts are conducted at long distance and it is impossible (or suicidal) to approach closely. Still photographs cannot convey what it feels like to experience, for instance, an earthquake or a flood. All they can do is to show isolated fragments from the continuing events. However, like jigsaw pieces, together they may form a reasonably true and comprehensible 'picture' – the individual *parts* may make up a significant *whole*. The human mind may be able to make sense of the many facets of great events and understand their implications, but all the photographer can do is attempt to capture for the reader the telling fragments from what is happening in front of the camera.

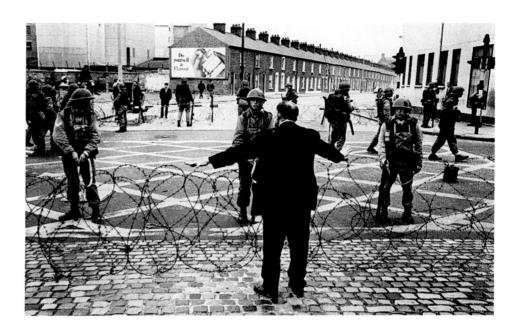

'All that you can probably do is indicate the cost in terms of human suffering. This can often be seen most vividly in the expressions on people's faces.'

Above The most telling news photographs of conflict situations are often fragments or vignettes that attempt to describe how these momentous events affect ordinary people. Fuelled by alcohol, this Belfast resident, on seeing British troops arrive in his street in August 1969, makes a futile gesture of pacification towards the young soldiers. It was an alarming confrontation tinged with pathos. Little did the people of Northern Ireland, and those witnesses from the media, realize that troops would be patrolling these streets for another 30 years. **PAUL HILL**

Facing Page The scale of war can be extremely difficult to convey in photographs, but the tragedy of it can always be seen in the faces of the innocent victims. The true cost of war is shown in this picture of a woman who has just lost her husband in fighting on the island of Cyprus in 1964. **DON McCULLIN**

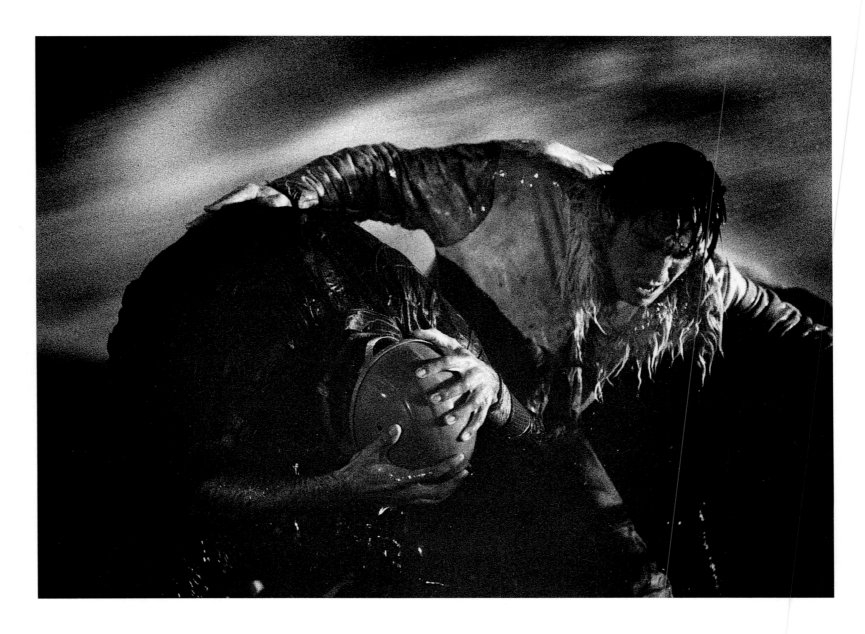

The photographer *has* to be where the action is, and only the photographs taken there can count. Photographs cannot give objective overviews. Commentators and historians may read the images in a way that is fundamentally different to the photographer's intentions. Captions can be used to help direct the reader, but their response can never be accurately anticipated. However, there are many instances where public opinion and social change have been affected by a photographer's pictures. This can be extremely gratifying, particularly when deprivation and injustices are remedied, but history has shown us that photographs can also be used for unsavoury propagandistic purposes.

Facing Page When major news events occur, magazines and newspapers dispatch small teams of photographers to cover them. Sometimes a photographer captures the action surrounding the event in a very dramatic and truly memorable way, as in this picture of anti-Nazi rioters being sprayed by a water cannon in Germany.
BRYN CAMPBELL

Right, Top and Bottom The interpretation of photographs can be very problematic, despite the photographer's attempts to direct the reader towards an understanding of the situation as he or she saw it. The violent clash between National Front marchers and anti-racists in Lewisham, London, in 1977, was a tricky situation to photograph, as different factions frequently attempt to make media capital out of such incidents. The media interpreted this riot in conflicting ways, and they tended to use photographs that supported their view of the clash. These pictures show two different sides of the riot. In one, a demonstrator appears to be a 'victim' of police action, and in the second, the 'victim' is a policeman. Everyone interprets these images according to their own political feelings, but it is easy to see how newspaper or magazine caption writers could influence your reading of them by what they wrote under the pictures. Frequently only one picture would be published, so the photographer's attempt to give a 'fair' and even-handed coverage of the clash would be negated. **CHRIS STEELE-PERKINS**

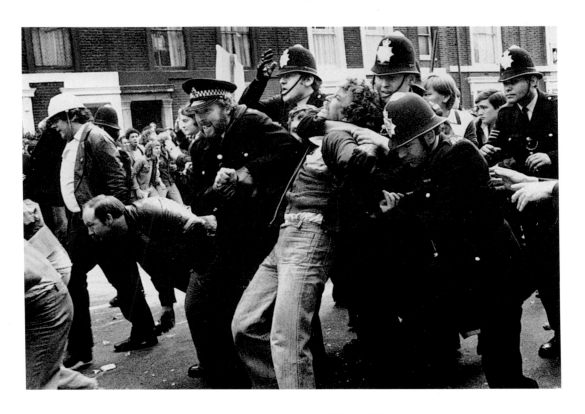

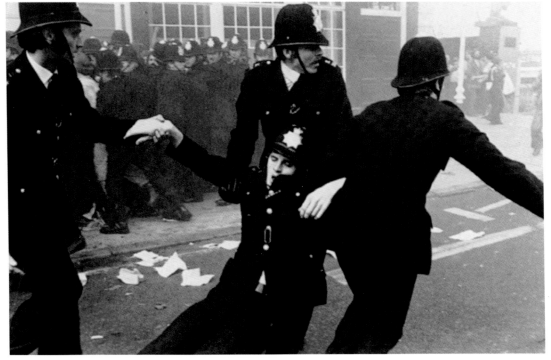

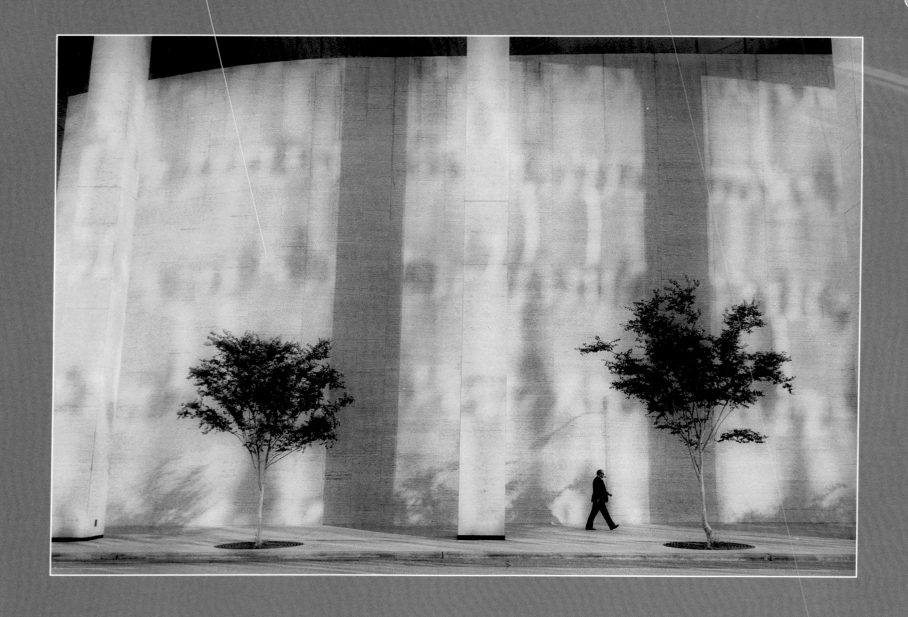

Chapter Six: **EXPERIENCING BEAUTY**

When you visit somewhere, what are the things you photograph to remember that place by? Why does everyone seem to select the same scenes? Mountains towering over the village in the foreground, the evening sun setting over the sea. Is what you photograph affected by the views you see in travel literature or on postcards? It is not surprising that you should be influenced by postcards, for instance, because there are so many

Seeing comes before words. It is seeing that establishes our place in the surrounding world.

John Berger
Art critic, novelist and
film maker

Below This gloriously romantic view by **FRANCIS BEDFORD** (*c*.1870) was typical of the type of photograph you could buy in certain outlets, near to the spot where it was taken. As Victorian photographers were influenced by the romantic landscape painters of the day, so generations of photographers have followed the pictorial landscape style that emerged at that time. The silky-smooth surface of the stream is caused by the long exposure it was then necessary to make to get a printable negative. *(Author's collection)*

1307 Watersmeet. The Two Streams.

Bedford

of them around, in attics as well as on display in retail outlets. In the nineteenth century, photographers were similarly influenced by the guidebooks that travellers used then. When commercial and amateur photographers visited a picturesque site, they referred to a current guidebook and positioned themselves to get the same view in the photograph that was so eloquently described in the book in order to 'transport' that landscape home.

'When commercial and amateur photographers visited a picturesque site, they referred to a current guidebook and positioned themselves to get the same view...'

At the time there was a 'wonders-of-nature' love affair between nineteenth-century aesthetes and the landscape. The celebration of Nature, manifested through painting and photography, was partly a form of immunization against the seemingly soulless march of industrialization. Ironically, however, the technological advances that industrialization heralded also led to the development of rollfilm and smaller, less complicated cameras. This meant that photography

Left Magnificent photographs of the landscape, like this mountain vista, are very striking. The sensuous undulations of the pure white snow catch your attention first, but when you notice the tiny figures of the mountaineers and their line of footprints, you become aware of the scale. You are able to relate, from a comfortable vantage point, to the human activity taking place.
BRADFORD WASHBURN
(Museum of Science, Boston)

Above There is a great attraction to this much-reproduced photograph of Heptonstall, Yorkshire, because it is 'beautiful' by our cultural standards. There may be a feeling of the unknown and mysterious, especially in a religious context (note the position of the church), but there is a warm feeling of harmony and timelessness in the picture too. It may not be so much about spiritual illumination as a reflection on some bygone rural idyll. **FAY GODWIN**

became available to everyone, and was no longer the sole preserve of an elite few made up of well-heeled gentlefolk and commercial operators.

'A photograph that attempts to show simply how wonderful nature is poses very few intellectual challenges.'

Landscape and Nature

How do you feel when you experience nature? Or when you stand on a high point and gaze at the landscape in front of you? Is what you photograph what you feel? Can your reactions be conveyed in a photograph anyway? A photograph that attempts to show simply how wonderful nature is poses very few intellectual challenges. It is a conservative artefact because it celebrates the status quo.

Left The natural 'beauty' of a snow-covered Scottish peak and the man-made 'ugliness' of the tarmac road are juxtaposed in this cover photograph from *Our Forbidden Land* by **FAY GODWIN** (Jonathan Cape, London, 1990) to produce a metaphor reflecting the environmental conflict between the two. But you could also read the image in another way and feel that the graphic quality of the road markings when integrated into the whole picture area makes a beautiful photograph rather than a comment on the environment.

The use of photography to promote conservation was particularly evident in the USA in the late 1800s. Photographs of remote and wild areas persuaded the authorities to establish certain parts of the USA (e.g. Yellowstone and Yosemite) as national parks, preserved for posterity in all their natural, untouched splendour.

Natural Landscape

Why do we hold the natural landscape in so much awe? Is it because we feel so small in it and, therefore, a little fearful? Landscape photographs are comfortable and reassuring by comparison. Of course, if we were actually at the place photographed our sensory faculties would respond completely differently to the way they react when viewing the photograph. A photograph of a landscape can be

Right Even unsightly industrial sites and environmental eyesores can be suitable aesthetic subject matter for a visually aware photographer, who in this scene saw the possibilities for making a subtly beautiful landscape photograph out of the tailings lagoon of a Cumbrian quarry. It is an expressively poignant image whose attraction is actually helped by the unsightly detritus.
MIKE HARPER

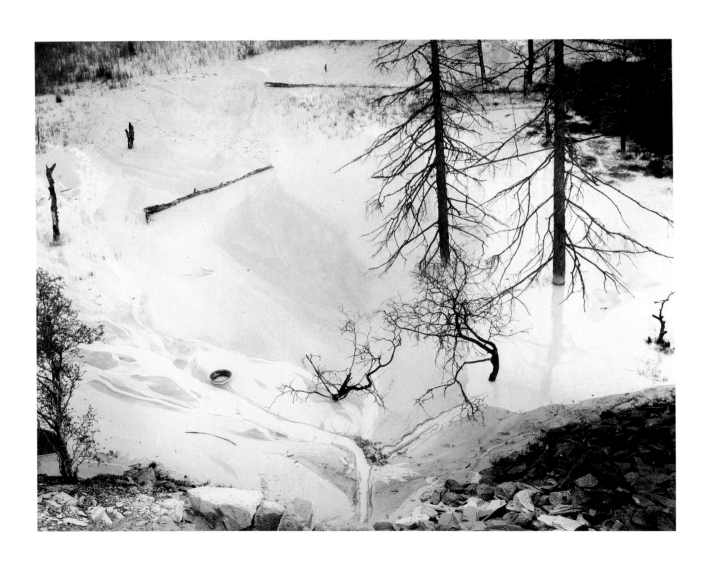

warm and appealing – so different to actually being there and having to cope with physical exertion, the weather and so on.

What moves us to call something like a sunset 'beautiful'? Objects do not have 'beauty' in the sense of possessing a thing called beauty. We impose the word beauty on things, and what makes it confusing is that there is no clear consensus on what 'beauty' actually is. Maybe we feel a sense of harmony, a soothing sensation or a gut feeling when we contemplate what are for us 'beautiful' things. Beauty is a thing you have to feel inwardly – never assume that what you think of as beautiful is going to be appreciated as beautiful by anybody else. And never let people brainwash you into accepting their definition of beauty as the only valid one.

'Beautiful' is also a convenient word frequently used to describe pictures, but it is an imprecise one, like 'nice'. It is much easier to appreciate the way someone crafts something, the manner in which a photographer presents the work, or the explanation the maker gives concerning his/her photographs.

But do 'beautiful' photographs – to return to the conservation issue – nonetheless persuade thousands of people to go to certain attractive and wild areas, thereby endangering their unspoilt character? The compulsion to find out how reality compares with a photograph is very powerful.

Photographs that promote the picturesque may be pleasant and soothing, but they confirm an idea of pastoral bliss, which may not be quite accurate. Is there a cement factory or an opencast mine lurking

The use of photography to promote conservation was particularly evident in the USA in the late 1800s. Photographs of remote and wild areas persuaded the authorities to establish certain parts of the USA (e.g. Yellowstone and Yosemite) as national parks, preserved for posterity in all their natural, untouched splendour.

Natural Landscape

Why do we hold the natural landscape in so much awe? Is it because we feel so small in it and, therefore, a little fearful? Landscape photographs are comfortable and reassuring by comparison. Of course, if we were actually at the place photographed our sensory faculties would respond completely differently to the way they react when viewing the photograph. A photograph of a landscape can be

Right Even unsightly industrial sites and environmental eyesores can be suitable aesthetic subject matter for a visually aware photographer, who in this scene saw the possibilities for making a subtly beautiful landscape photograph out of the tailings lagoon of a Cumbrian quarry. It is an expressively poignant image whose attraction is actually helped by the unsightly detritus.
MIKE HARPER

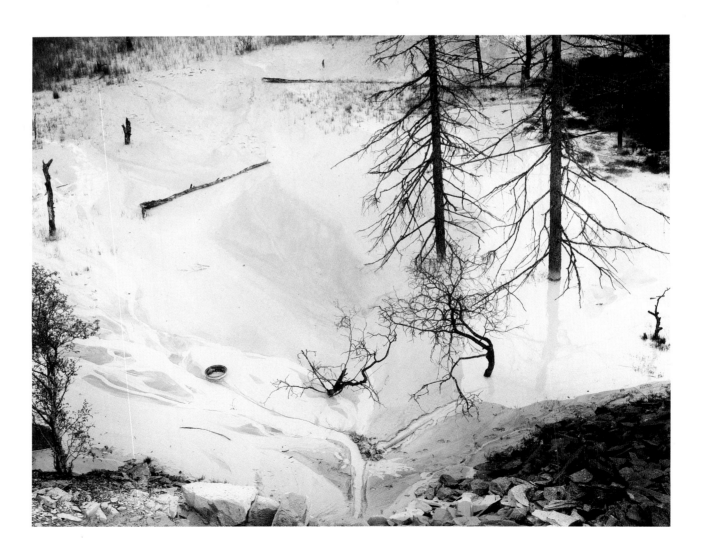

Natural, and manmade, objects photographed in exemplary detail can celebrate the thing itself by intensifying the viewer's awareness of the subject matter. These two classic studies, one by **EDWARD WESTON** *(Pepper No.30, 1930)*, and the other by **PAUL STRAND** *(Lathe, New York, 1923)*, are perfect examples of the 'straight' approach to photography that directed the medium away from sentimentally romantic pictorialism towards a more photographically objective style. The consummate craftsmanship employed in the making of these prints also demonstrates the inherent qualities of the 'fine' print. *(Courtesy of the Estate of Edward Weston; courtesy of the Estate of Paul Strand)*

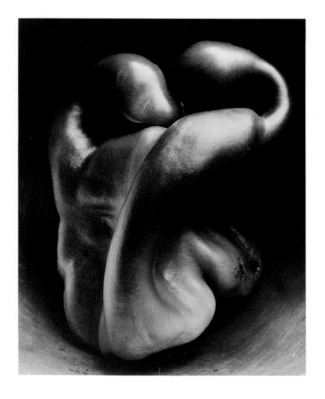

warm and appealing – so different to actually being there and having to cope with physical exertion, the weather and so on.

What moves us to call something like a sunset 'beautiful'? Objects do not have 'beauty' in the sense of possessing a thing called beauty. We impose the word beauty on things, and what makes it confusing is that there is no clear consensus on what 'beauty' actually is. Maybe we feel a sense of harmony, a soothing sensation or a gut feeling when we contemplate what are for us 'beautiful' things. Beauty is a thing you have to feel inwardly – never assume that what you think of as beautiful is going to be appreciated as beautiful by anybody else. And never let people brainwash you into accepting their definition of beauty as the only valid one.

'Beautiful' is also a convenient word frequently used to describe pictures, but it is an imprecise one, like 'nice'. It is much easier to appreciate the way someone crafts something, the manner in which a photographer presents the work, or the explanation the maker gives concerning his/her photographs.

But do 'beautiful' photographs – to return to the conservation issue – nonetheless persuade thousands of people to go to certain attractive and wild areas, thereby endangering their unspoilt character? The compulsion to find out how reality compares with a photograph is very powerful.

Photographs that promote the picturesque may be pleasant and soothing, but they confirm an idea of pastoral bliss, which may not be quite accurate. Is there a cement factory or an opencast mine lurking

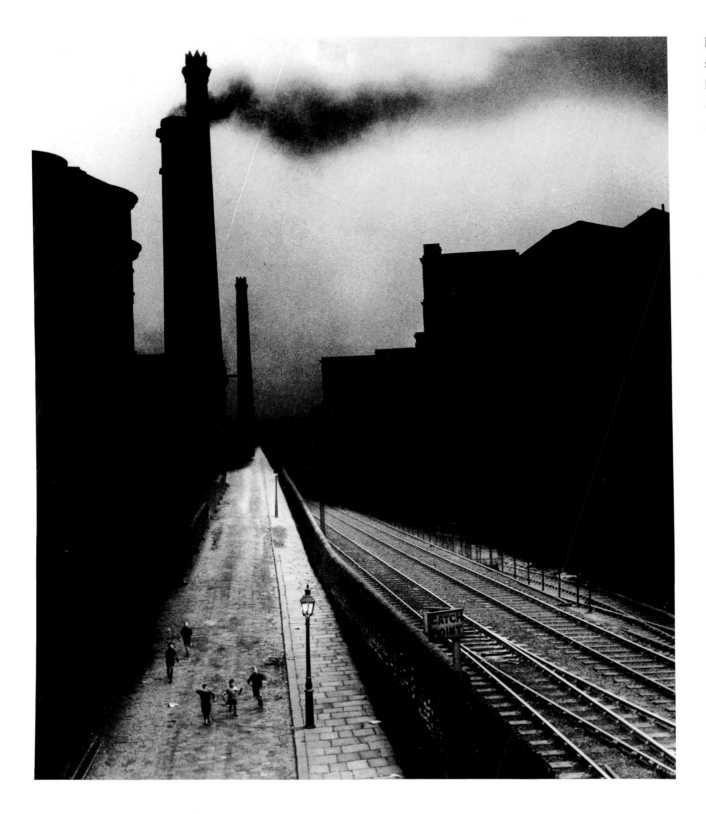

Left An image of the dark satanic mills of Northern England – all dirt and deprivation – appears to be portrayed in this famous photograph of Halifax taken in the 1930s. But the stylized printing methods employed make it an excellent example of chiaroscuro, rather than social documentation. The documentary photograph becomes an art object.
BILL BRANDT

Below and Facing Page The propensity for photography to 'beautify' everything can clearly be seen in these two exquisite photographs – one of a factory and the other of an office block. These normally aesthetically ignored subjects are transformed in one case into a graphic and tonal exercise, and in the other to a visual poem about light and scale.
LEWIS BALTZ and **MICHAEL ORMEROD**

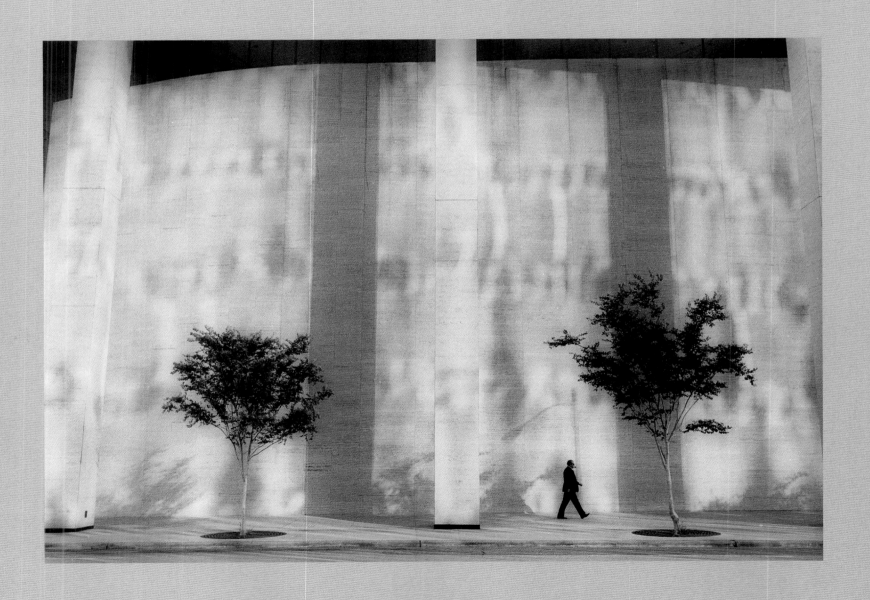

just out of frame beyond the leafy bower and the twinkling stream? And if there are such things there, is it not more honest to include them in the picture too? Would the juxtaposition of the 'ugly' and the 'beautiful' not make the viewer more aware of what mankind is doing to the natural landscape?

Manmade Landscape

The topography of a place may also, of course, show the obvious influence of man. Many photographers prefer this form of landscape to the one created by nature. There is a fascination in what civilization constructs and leaves behind. Much visual pleasure and cultural and historical

BEAUTIFUL SCARS

Even 'ugly' manmade things can be beautiful if they are photographed with aesthetics in mind. Grim factory walls may 'imprison' exploited workers and unsightly mines may 'scar' the countryside, but that does not mean that photographers have avoided making beautiful photographs of such things. As we know, beauty is in the eye of the beholder, but to the camera's neutral eye all subjects are seen in the same way. Light is the same whether it is reflected off terracotta tiles or corrugated iron. Photographs of walls on their own will never convey imprisonment, but, ironically, barbed wire round a nature reserve might. You should not let such paradoxes confound you – better to exploit them!

information can be gained from photographing what man has built. Buildings can be photographed in order to show their grandeur or their monumentality, the skill of the architect or the builder, or to evoke mood and atmosphere.

The straight approach is the best one if the photographer wishes to be objective. With this approach the aim is to allow the subject to be seen as what it is. The world is made up of objects that fascinate when examined in detail, whether they are natural or manmade. To photograph the thing itself means just that. The presentation of the object(s) in accurate photographic detail is sufficient; its qualities should be self-evident and self-conscious interpretation by the photographer unnecessary. The aim is to intensify the viewer's awareness of the subject matter. Large-format view cameras are often used to obtain this visual clarity. (Advertising photographers also use the same technique for their highly detailed still-life 'pack shots' to emphasize the fine quality of the product being promoted.)

Home Environment

When we think of places to photograph we rarely consider our own immediate environment, probably because we cannot see any interest in what is closest to us. We feel that the interesting and the unusual lie far away, but the search for the exotic is often anti-climactic and conventional views that will just confirm that you went to an interesting place can be the only pictures that are produced. Photographs have to generate more than

'There could be as much grandeur in a photograph of forms made by the light and shade on the back wall of your house as there is in the picture of a distant mountain range.'

Right The search for the exotic does not have to take you to faraway places. Night shots in leafy, mock-Tudor suburbia can reveal some strange things too. So it may be a good idea to look in your own backyard before embarking on journeys to unusual places and foreign lands. Horse-chestnut leaves can look like tropical plants when their shadows are cast by light (in this case) from an ordinary street lamp. **PAUL HILL**

envy in the viewer. They should attempt to illuminate and excite, not reinforce a stereotyped vision of the world that we are often in danger of receiving from teachers, commerce, or from the media. It is necessary to try to capture the mood and spirit of a place (whether it is 5000 miles or 50 yards away from where you live) if you want to reveal anything original. There could be as much grandeur in a photograph of forms made by the light and shade on the back wall of your house as there is in the picture of a distant mountain range.

With the easy availability of air travel and relatively cheap package tours, exotic locations are easily reached, and as we are all aware photographs are used to help sell the 'magic-carpet' dream. This is why we always get a favourable and idealized impression of tourist destinations from brochures.

The 'Fine' Print

The idea of beauty may be central to the way you photograph a landscape, whether it is formed by nature or by man. If this is so, it should be echoed in the photographic print – when the quality of vision and the excellence of craft come together. If you feel an affinity with the landscape, this can be brought out in the warmth of the tones in the print. In special bromide printing papers, brown/olive-green tones give this type of warmth, whereas blue/black tones have a comparative coldness. If the landscape is bleak and harsh, the latter tonal quality will probably be the most appropriate. Using different print developers and special toning solutions can also alter the tonal 'colour'.

The type of surface of the paper is also important. A matt surface will appear 'dead' in comparison to a glossy surface, because it is a poor reflector of light. The way the paper is coated with the various necessary chemical compositions can also radically affect its 'luminosity'. Many photographers prefer a glossy, porcelain-like surface as this has a sensuality that may correspond to the surface of the objects photographed. Some photographers coat their own papers – as in the nineteenth century – with silver and non-silver (e.g. platinum) emulsions so they can obtain the tonal colour and surface texture they require. With these processes the image appears to reside in the paper rather on the surface of it. They also have to use contact printing, which means the negative has to be the same size as the end print – usually 5x4 or 10x8 inches. An ultraviolet lamp or sunlight are the normal light sources rather than a darkroom enlarger.

These processes require skill and patience – and the materials are not very easy to find or control – so you really have to enjoy producing carefully crafted prints. It can, however, be very fulfilling to create a work in this way. But be careful of too much fetishism in printing, as a luscious print can often mask a thin idea.

Facing Page There can be almost as much handwork in 'alternative' photographic printing processes as there is in traditional fine-art printing. Here, a recent pioneer of non-silver printing processes, **DR MIKE WARE**, has made a cyanotype photogram (he calls it a cyanogram) by laying a grass stem on watercolour paper coated by his own homemade emulsion. This contact print clearly shows that the specially made chemical mixture has been brushed on, giving the work an authentic handcrafted look.

Tilas 2000 Cyanogram Mike Ware

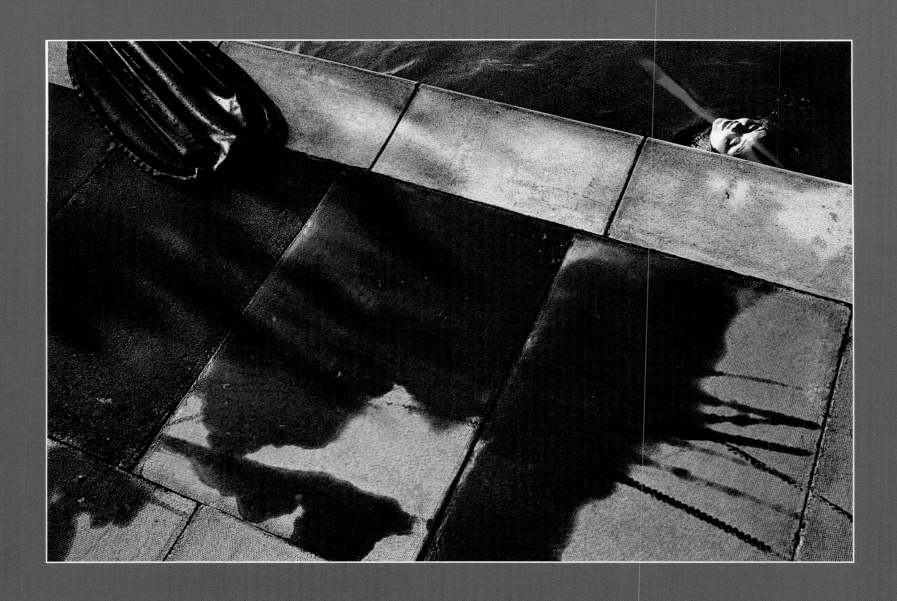

Chapter Seven: **IN SEARCH OF SELF AND THE METAPHOR**

> Photographs, which cannot themselves explain anything, are
> inexhaustible invitations to deduction, speculation and fantasy.

Susan Sontag Critic and novelist

Photographs that set out to be metaphors for the feelings of the photographer are both difficult to accomplish and hard to understand straight away. To attempt to show our emotions, state of mind or psyche in photographs could appear futile, given the seeming objectivity of the medium. Emotions can be difficult to portray because of their ephemeral quality, but as they govern much of our behaviour and continuously affect our lives, they can hardly be ignored.

The psychological approach does, of course, make the photographer very vulnerable, as the pictures may be embarrassingly personal or overbearingly symbolic. But if your emotions and inner feelings are honestly expressed, you are less likely to be accused of pretentiousness or self-obsession.

Self-expression

Even if photographers produce highly subjective 'psychological' photographs, the influence of their particular culture and society is certain to be reflected in the work. One's self is a fundamental part of subjective thinking, and thus integral to conveying feeling within a photograph.

As a photographer you record what is 'out there' in the world, and so you have to select from all that wealth of material the specific motifs that can act as vehicles for your inner feelings. The selection you make reveals how you feel – or want to appear to feel – about the subject, its content or its form. In that sense all photographs are to some extent self-portraits, whether you directly include yourself in the picture or not. You can, of course, incorporate yourself in the image obliquely by showing your shadow or reflection – although these could be considered by many to be compositional faults. Alternatively, you may use another person or object to represent your alter ego. The appearance

'The appearance of the photographer in the actual image should not be considered egocentric. It may simply show that the photographer wants to put him or herself "on the line"...'

of the photographer in the actual image should not be considered egocentric. It may simply show that the photographer wants to put him or herself 'on the line', in preference to 'hiding' behind the people, places and events in front of the camera.

Some hint of your personality always emerges from your photographs, even if they were just meant to be records. Other people can often perceive the 'real' you coming out in your pictures; the trick is to try to divine the personally significant images for yourself. If you succeed in finding this out, you are better equipped when it comes to making the sort of photographs that are most relevant – and revelatory – to others.

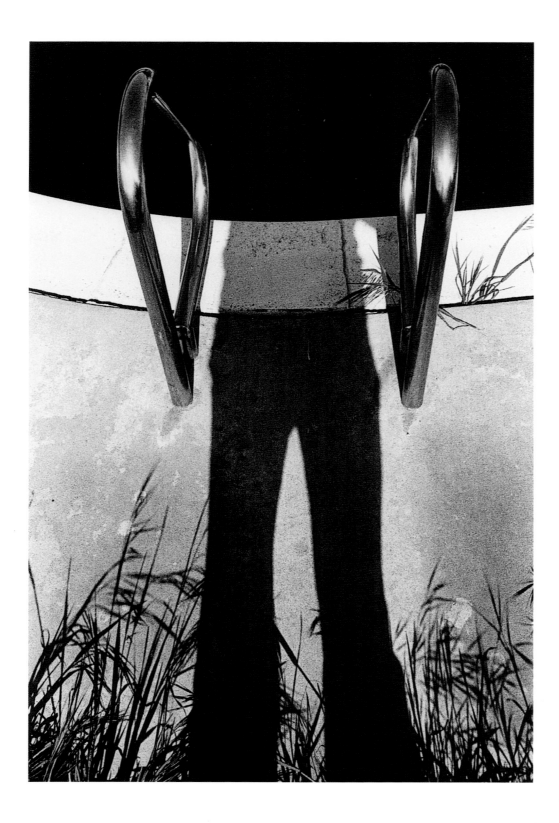

Left By including his shadow, the photographer has inevitably personalized the image. The ambiguity in the picture is used to increase the sense of unease that can often come from ordinary situations photographed in a very subjective way. The swimming pool rails become his 'arms', the water appears to be a featureless abyss, and the concrete in the foreground looks like the sky.
PAUL HILL

Below To photograph what you feel rather than what is in front of the camera can seem a daunting task given the medium's representational facility. The metaphor can also appear inscrutable if too much emphasis is laid on deciphering the objects in the picture. The wooden stakes impaling the anonymous body of a person (who appears about to be guillotined), while strange animals in human clothing lurk among the trees, are elements that can be recognized and mentally catalogued. But on an emotional level, what might this ambiguous image evoke in the viewer? **PAUL HILL**

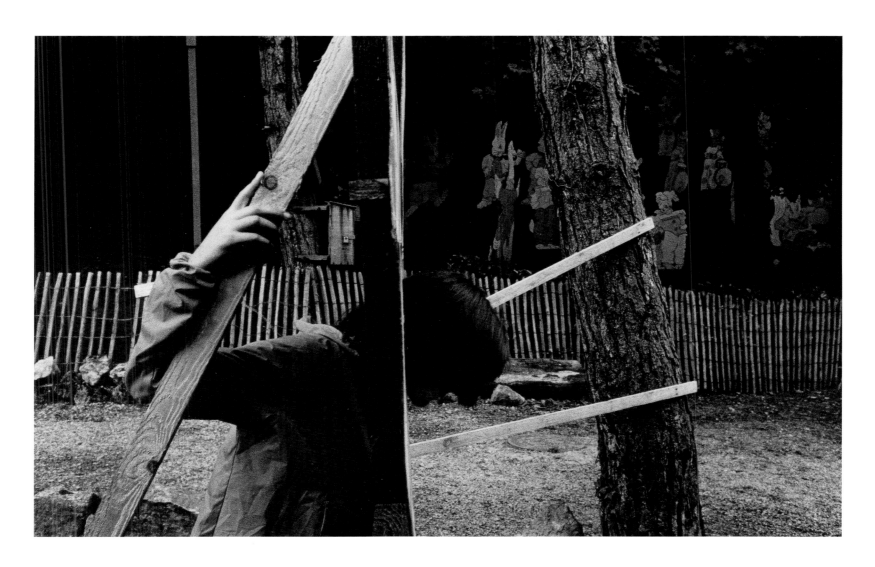

Reflecting the Human Condition

You may find that you often photograph your family – the institution that probably affects you the most (positively and negatively). If you care deeply about those nearest and dearest to you, it will be noticeable in the pictures. Anyway, why photograph subjects you may feel ambivalent

'By metaphorically holding up a revealing mirror to ourselves we may symbolize more than our own vulnerability – we could echo some of the emotions and inner feelings that affect us all.'

about when those you really care for reside in the same house as you? The ordinary and the extraordinary things connected with existence – the joys and the traumas – often happen in and around your home and family. This should be reflected in your photographs of these subjects.

Human beings are very curious (in both senses of the word) animals, and our attention is frequently attracted by the strange behaviour of others. Photographers continually photograph the behaviour and actions of their fellow humans; they even diligently search them out. But must the photographer always be the hunter? Is he not a victim too? Photographers are part of society and just as vulnerable to its vagaries as anyone else. By metaphorically holding up a revealing mirror to ourselves we may symbolize more than our own vulnerability – we could echo some of the emotions and inner feelings that affect us all. Surely if photographers know themselves better they may be able to comprehend and, in turn, correctly interpret the actions of others more easily.

Facing Page The inclusion of one's self, physically and/or metaphorically, in your pictures can be embarrassing, but it is usually the most revealing thing you can do with a camera. Here, the photographer interprets a Swedish myth reflecting sexual and gender roles using herself as the subject matter. There is a strong element of performance, with the use of white make-up and a balletic position, which is accentuated by the blurred arms (she used a slow shutter speed) that resemble wings. **ASA NYHLEN**

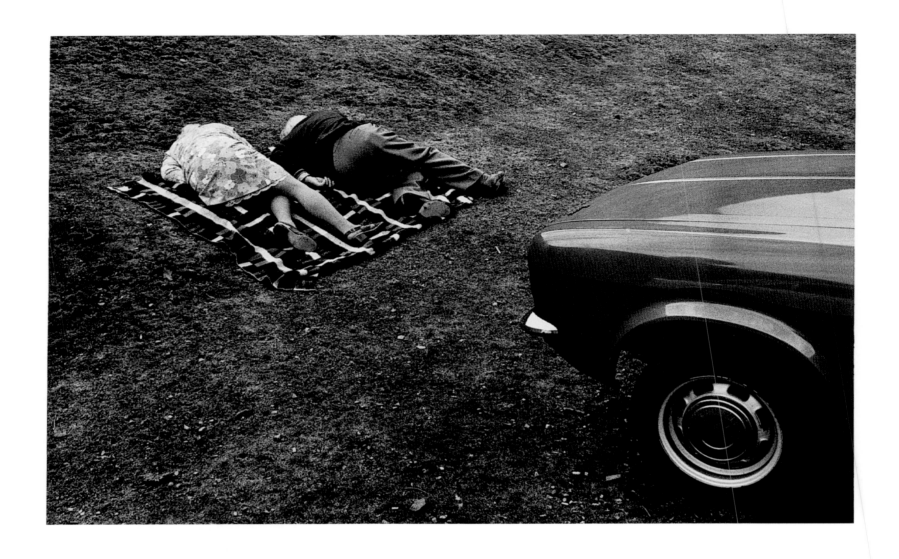

Above Human relationships (in this case man and wife) are the subject of a great deal of photographic imagery. But with this picture there is an unsettling sense of mystery and menace. Are the old age couple sleeping peacefully on a day trip to the country or are they in danger of being run over by the car? This is, of course, a perfectly natural and innocent scene, but the metaphoric potential of juxtaposing the two disparate elements has been recognised by the photographer and the elimination of other reference points, by careful framing, reinforces this.
PAUL HILL

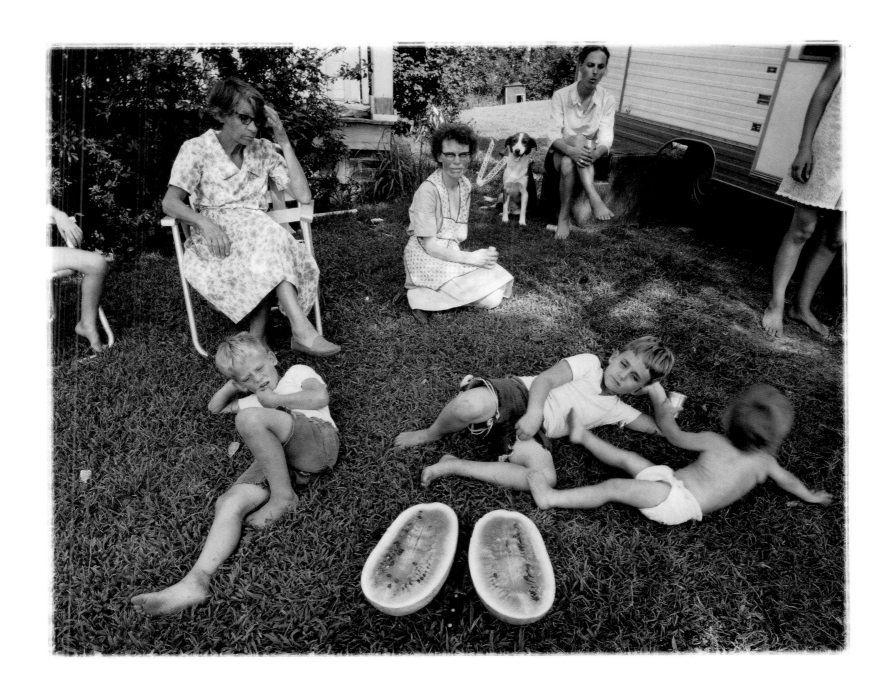

Above Photographers frequently use their families as continuing motifs and themes for their
work. In this photograph, a moment is caught when nearly all the family seem lost in their own
thoughts. It could be interpreted as a metaphoric tableau that uses, idiosyncratically in this
instance, the watermelons as the focal point for the eye to radiate from. **EMMETT GOWIN**

We are all part of the human condition – that blanket phrase, which is meant to convey our weaknesses and strengths, loves and hates – and therefore we should not abdicate our responsibilities. Photographs are made by human beings for consumption by other human beings. If you seek to follow the personally expressive (self-portrait) road, the most important attribute may not be your technique or vision, but your integrity. It can be a road strewn with spurious intentions and flawed egos, so it is important to remain honest.

Photography can be a formidable tool of investigation as it provides immediate first-hand experience of the many mysteries around us: the mysteries of science, nature and society – and of our own selves. There are two areas of consciousness – the world of the imagination and the real world – and photography has the ability to combine the two.

For many photographers the quest to reveal the 'otherness' of existence – the spirit or essence – is paramount. The search to attain this heightened awareness through photographing seemingly ordinary subject matter can be frustrating and the end result often anti-climactic and disappointing. The craved-for objective may be just a figment of the photographer's imagination and impossible to capture via photography.

So to appreciate photographs that represent inner – and probably indefinable – feelings is an act of faith. It would be invidious to attribute any objective significance to the subject matter in such

'The craved-for objective may be just a figment of the photographer's imagination and impossible to capture via photography.'

photographs; the aim is to appreciate their symbolic and metaphoric qualities, and the work should strive to transcend the physical nature of things.

Spirit of Place

Photographers often seek locations that evoke a certain atmosphere or spirit of place. They wish their images to transmit an ethereal 'presence' (despite the seemingly mechanistic and utilitarian nature of photography). They hope their photographs will be imbued with an 'otherness' that is reality to them. This approach has a spiritual quality that verges on mysticism and thus alienates a great many people, who prefer a more rational use of photography. These photographers also have a tendency to make fine-quality prints that then become precious objects in their own right. This is not out of pretentiousness, but because it is also a part of the experience for the print to be an appreciated thing too. The print is an object to be cared about in a world where most photographs are not; it is an artefact to be contemplated and meditated upon.

Facing Page Quiet, apparently 'secret' places are sought out by many landscape photographers because they seem to be imbued with a sense of mystery or 'otherness' that attracts them inwardly. In this picture there is also something disquieting about the way the 'fingers' of the tree appear to be clawing the ruined building. Such photographers nearly always make high-quality prints, full of detail, that seek to evoke contemplative responses from the viewer rather than produce an accurate record of what is in front of the camera. **THOMAS JOSHUA COOPER**

Above The touching of heads as an equivalent of some human gesture of anxiety is a possible interpretation of this image, whereas another might be to see the white shape in the centre as a more optimistic symbol. Photographs are catalysts for the viewer's feelings as well as for those of the photographer. Many photographers prefer to celebrate the world of the imagination rather than material existence in their work. **PAUL CAPONIGRO**

Above Here the floating reeds form shapes that are mysterious and evocative in this sylvan setting. The seductive tonal qualities of the print draw the viewer into the photographer's exploitation of the metamorphic potential of the photograph. **JOHN BLAKEMORE**

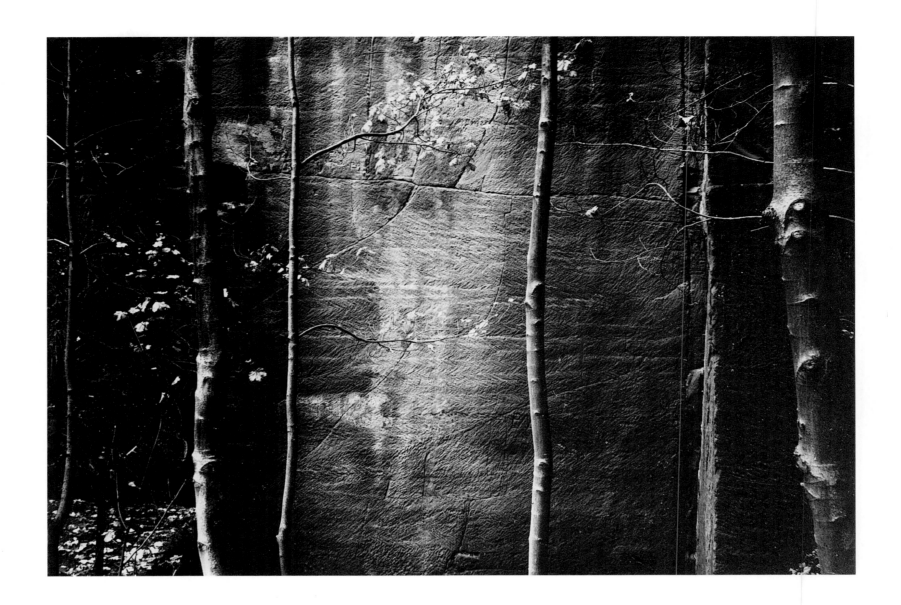

The natural landscape is nearly always the motif used for this kind of work. But the 'spirit' of a place can be felt in some manmade locations that evoke similar responses.

What is important is the intuitive response to a situation. There is often an instinctive appeal of a particular place that is difficult to pinpoint but is nonetheless there, like some unseen force of attraction. Of course, intellect, rather than instinct, plays a major role when it comes to how the photographs are made. But the emotional and sensory reaction to something is often a stronger motivator than an intellectual one.

More 'sense' can be made of the picture at the printing stage, as post-visualization frequently reveals hitherto unknown elements in an image. This can provide an additional 'journey of discovery', but do not expect it to be always a fruitful one. A 'presence', which could be conveyed, for example, through something as transient as light, has to be captured by a camera, just like the fleeting gesture made by someone in the street.

An intimate relationship with the print is crucial in this area of photography and, therefore, the portfolio is the best context for such work. Another vital factor is the sequencing of the prints. This is done best by laying out the prints and experiencing the interrelation and correlation that takes place. The work should be considered at length before it can 'speak', because at first glance only the 'surface' may be visible. A sequence should provide us with an experience that affects us emotionally or spiritually, even subconsciously. It is a psychological document that should be as culturally relevant as any good piece of social realism.

This apparently mystical – even ritualistic – approach to photography confounds many people, though they would probably be the first to admit that even in the real world there is still a great deal that is mysterious. The interpretation of a photograph can be as varied as the individuals

> '*A sequence should provide us with an experience that affects us emotionally or spiritually, even subconsciously. It is a psychological document that should be as culturally relevant as any good piece of social realism.*'

who look at it. If the viewer is unable to appreciate the transcendent aspect of a photograph, at least he or she still has a representation of an object or scene and normally a finely crafted artefact to enjoy. There is no medium or discipline that can offer so many positive options.

Pages 128–32

In a personal sequence, the visual and/or emotional interrelation and correlation of images should be aimed for, rather than a chronological or purely intellectual progression. In **(a)** and **(c)** the gesture of the hands and their contact with opaque surfaces provide a link. The shape of the telephone poles in **(c)** is echoed by the road and the rock ledge in **(b)**, where, again, a part of the body is used metaphorically. The arrow-like triangular shape – evident in **(a)**, **(b)** and **(c)** – surrounds the head in **(d)**. The ledge of **(b)** and the edge of the swimming pool in **(d)** are horizontal objects that have become vertical, with the edge in **(d)** seeming to push the head (and, therefore, the focal point) out of the picture. The human figure becomes more dominating again in **(e)** – perhaps it is the person in **(d)**? The wedge shape appears again, this time surrounding a cricket match in the distance. The central motif of this 'sequence' is children, whose innocent activities have been transformed by the photographer into apparently stressful situations. In the same way as children over-dramatize their play, so the photographer has used the camera to draw attention dramatically to the tension and anxiety that pervades our everyday lives – not only in visual terms but by using the most vulnerable beings in our society as the thread that holds the 'sequence' together.
PAUL HILL

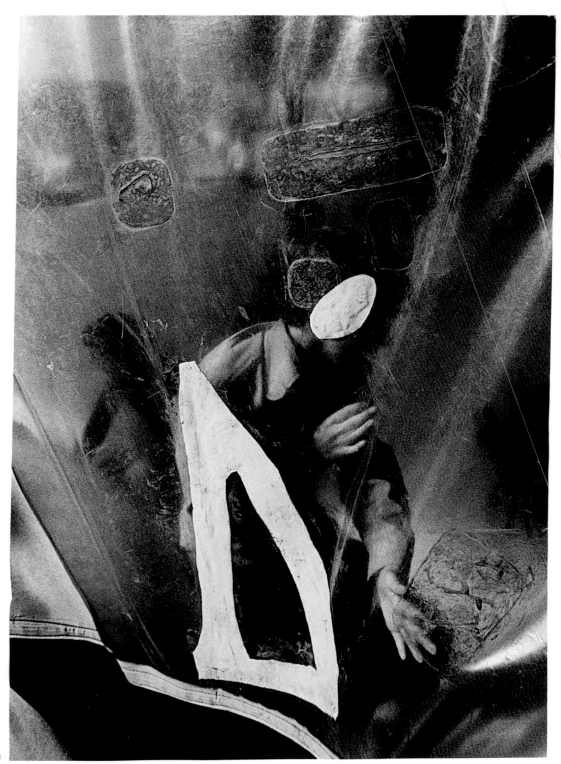

(a)

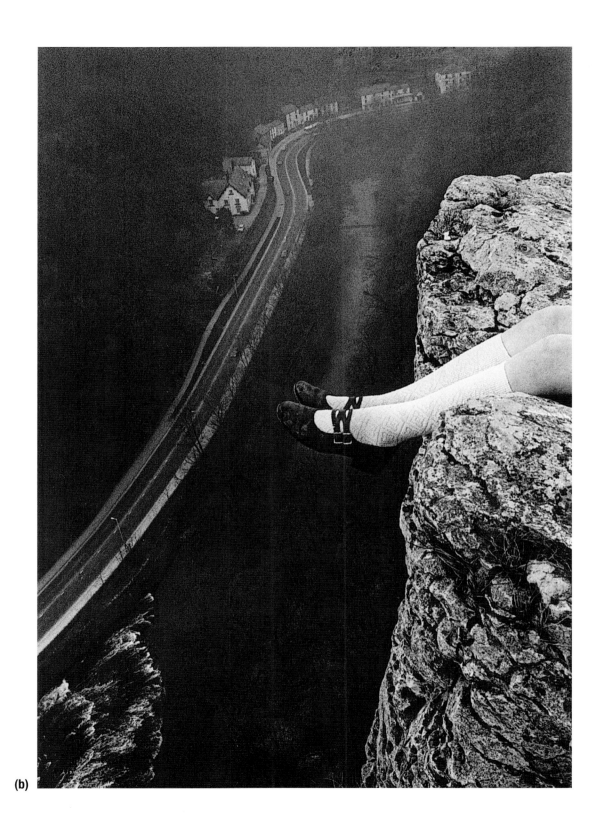

(b)

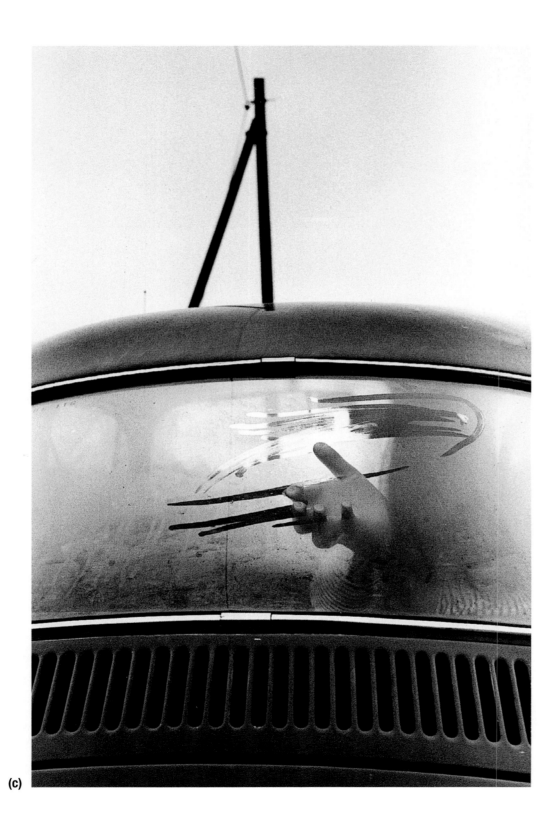

(c)

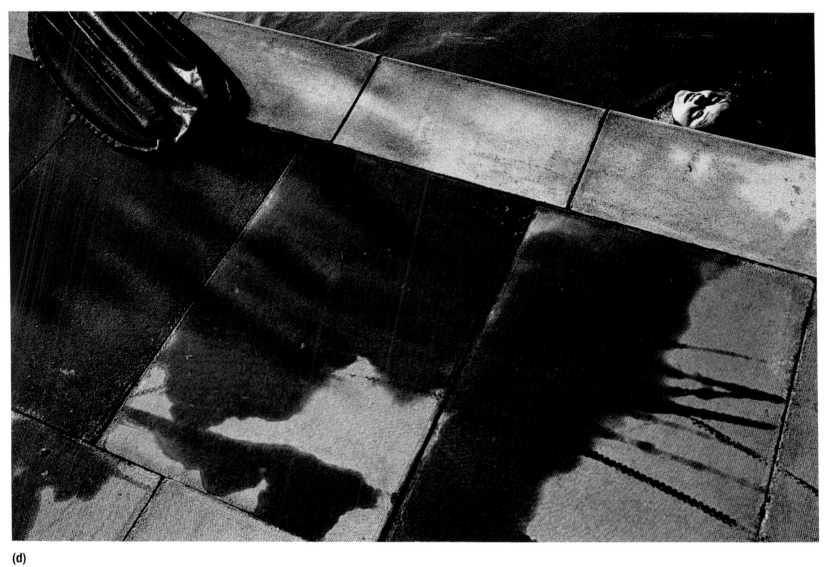

(d)

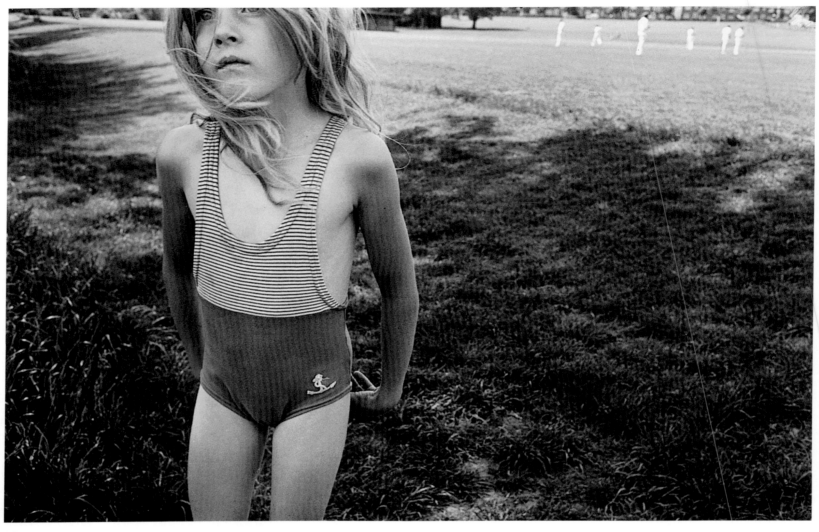

(e)

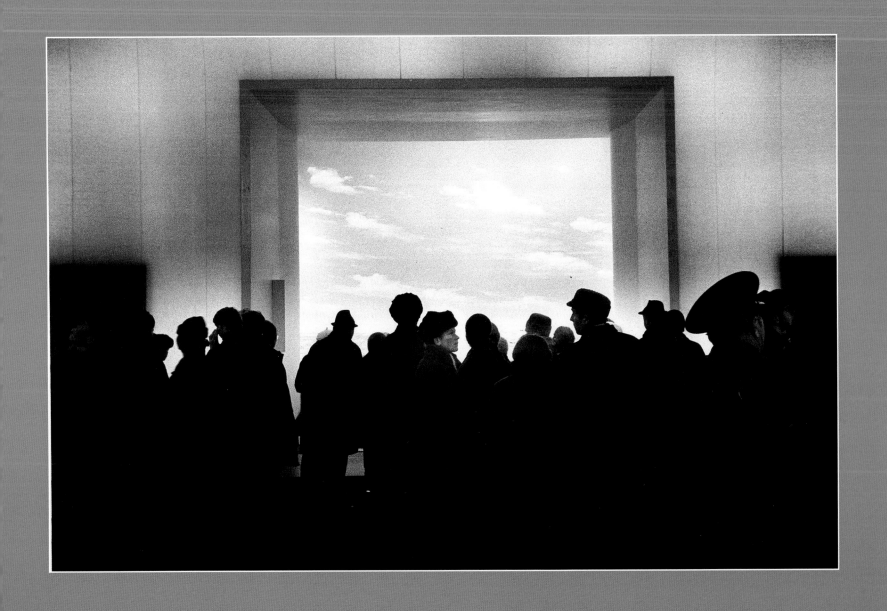

Chapter Eight: **FROM PRINTED PAGE TO GALLERY WALL**

Today, there is a more or less universal acceptance of photography as an important medium for personal expression. That does not mean to say that a great deal of subjective work is accepted by the majority of people – far from it! It is only relatively recently that photography has acquired an increasingly respectable place in galleries, museums and public collections. To collect contemporary photographs that were not of items like steam engines or pop stars would have been thought of as very odd until the 1970s, and very few publications used thought-provoking photographs. This was due largely to the limited ambitions of most photographers and also to the sort of designers

'To collect contemporary photographs that were not of items like steam engines or pop stars would have been thought of as very odd until the 1970s...'

who delighted in cropping photographs, who put captions and headlines on the actual images, or who spread a picture over the page fold, destroying its composition.

Word-orientated editors and ambitious graphic designers were (and in many cases still are) more than a match for all but the toughest of photographers. And even the few who fought back could be fired for daring to 'interfere' with matters that did not concern them – like the presentation of their own photographs. By-lines (the photographer's name) were very rare – very different to today, when everything is credited – and photographers had virtually no say in what was published and how it was presented.

New Outlets

Paradoxically, one of the events that affected this fairly recent awakening has been the global spread of television. It may have adversely affected the world of news magazines and photojournalism, but it did force many photographers – faced with diminishing markets for their documentary work – to consider new outlets and new forms for their talents.

Many went into television, while others gravitated to a much more personal approach that directly reflected their own feelings, points of view and concerns, and not those of the papers or magazines that they had worked for. They sought new, less compromising career paths more sympathetic to the subjective approach, like teaching, independent publishing and exhibiting.

The cultural cognoscenti were also discovering photography. Many former photojournalists and studio photographers began to sell their work like fine artists – and for similar prices. Photography also became a respectable art subject at universities

When asked by students, 'what are the theoretical implications of this?' my advice always was: 'Shoot first, ask questions later!'

Victor Burgin
Artist and academic

Facing Page The alienation and disaffection is easy to see in modern cities and this picture is aimed to portray that. The juxtaposition of the gilt-framed photograph of a rather apprehensive child against the disfiguring graffiti on the outside of the shop may suggest this. The truncated portrait and the child's expression may also symbolize the pathos of a situation in which spiritual claustrophobia and material survival miserably coexist. **PAUL HILL**

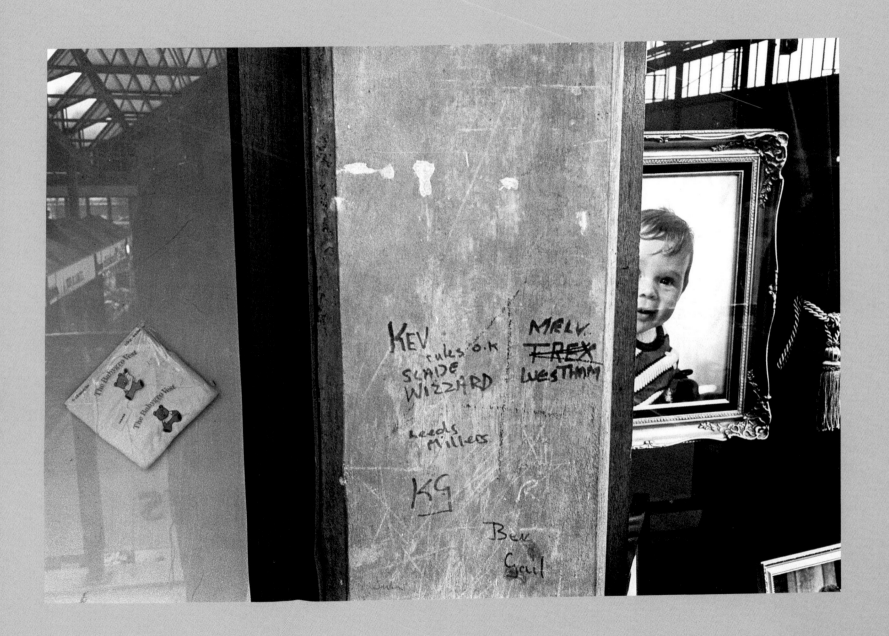

and colleges, warranting the award of a degree. Academia replaced corporations for many photographers who now had the opportunity to escape the conventional commercial world dictated by fads and deadlines. The money was not as good, but creative freedom and job security more than compensated. Photography had now become academically and artistically respectable and, understandably, the introspective mode was the most fashionable one.

New Documentary

The very personal documentary approach is not concerned with warm, affirmative magazine-orientated photo essays, styled as a 'Day in the life of...'. It adopts a more realistic – though often sardonic – view of the environment and the workings of modern society as the photographer, rather than an editor, sees them. Most of these personal documents are more than pictorial representations; they normally have an edge to them as the subject matter is usually urban and is often the street (and all that goes on in and around it). People become anonymous or 'types'. They are often unaware actors in scenes orchestrated by the photographer who uses elements from the real world to create what could be described as a psychological landscape.

The inherent ambiguity of photography can be used to emphasize the alienation and disaffection that many photographers perceive in modern society. Photographs can often hauntingly evoke the sometimes surreal quality that is apparent in our surroundings. Chance encounters and unusual juxtapositions are important features. The natural landscape has its 'secrets', but a sense of peace and security tends to pervade it. But a sense of anxiety resides in the metropolis most of the time. Surrealism and photography conspire most effectively in this environment.

Surrealism

Surrealism as a movement took shape in the 1920s and photography was very much an integral part of it from the beginning. The surrealists claim that the subconscious harbours a reality different to, but just as strong as, the one we experience in actuality. The movement emerged at a time when many artists were greatly influenced by Sigmund Freud's dream analyses and investigations into the subconscious. Artists felt that the subconscious,

'The extraordinary, or "unreal", is there amid the ordinary and prosaic, if we have the perception to see it.'

rather than conscious reason, should guide their work. A great many surrealistic paintings are strange and exotic fantasies, whereas the most successful surrealistic photographs show how strange the camera makes our everyday world look. In our dreams, our being and our world become distorted – 'unreal' – because our subconscious has taken over. The photographer can show a disjointed view of the world, but the vision is believable because we know he or she must be photographing things that really do exist.

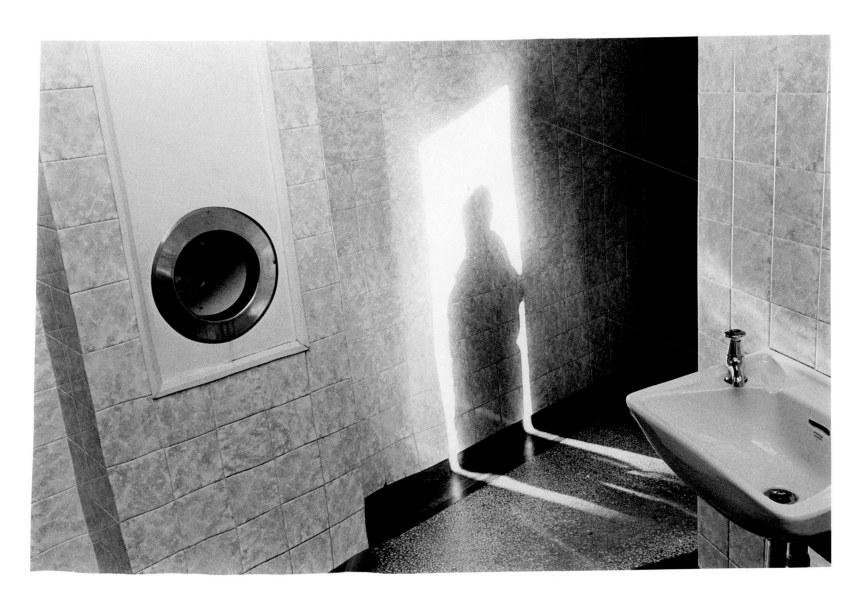

Above There is a pervading anxiety in many urban environments that is reinforced by the stories and programmes concerning violence and despair seen in the media. Who does the shadow in this picture belong to? What goes on in the chrome and ceramic-tiled room where the photograph is taken? The photographer relies on our fear of the unknown and the mysterious to imbue the image with a threatening atmosphere, perhaps hinting at an imminent danger. **PAUL HILL**

Above and Facing Page There is a 'surreal' quality to this photograph of a solitary figure looking – where? The *human* presence in many *contemporary* photographers' work *appears* somnambulistic and *can* often hauntingly evoke the bizarre atmosphere of such *situations*. In the other image the girl *looks* at what? Her 'decapitated' mother/sister/friend? Or has she just been 'blinded' by the *sun*? **DEBORAH BAKER**

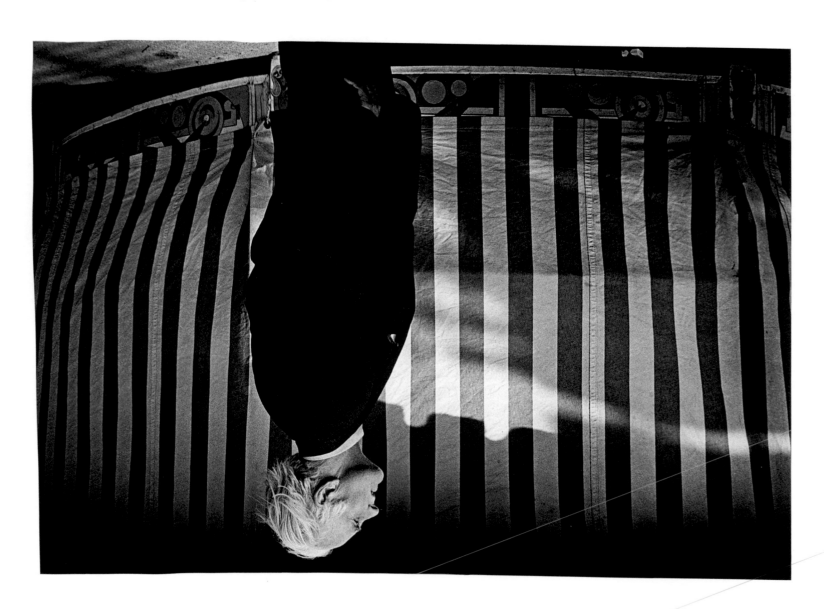

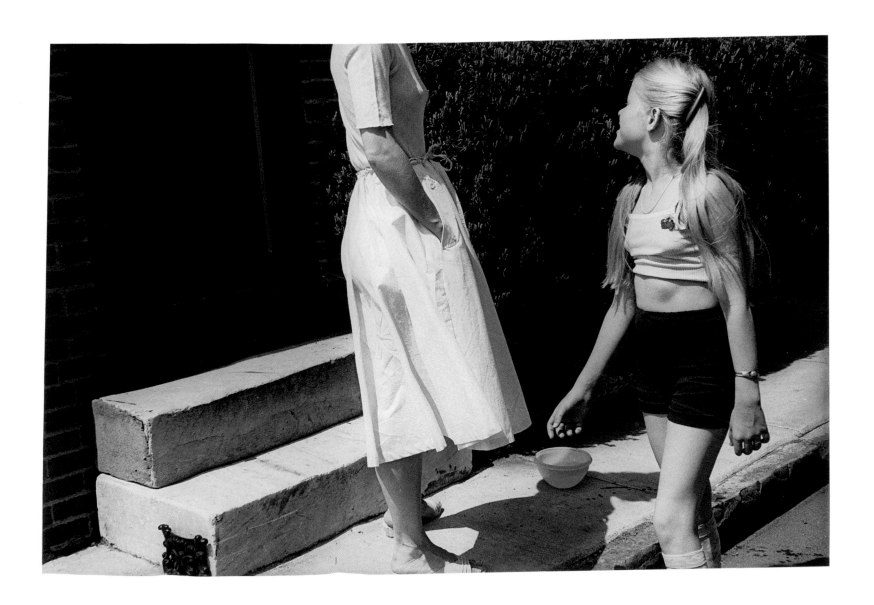

The extraordinary, or 'unreal', is there amid the ordinary and prosaic, if we have the perception to see it.

The camera's frame is often used as a 'cutting edge' that can appear to truncate people and objects. Wideangle lenses, which distort optically, are used to construct exaggeratedly surreal pictures. Feet can be made to appear as big as doors and ears as large as rocks. In this world of visual hyperbole, situations are not what they seem to be. Ordinary objects can become anthropomorphized, and the human body can turn into a landscape. Photography can turn human faces into masks and make tailor's dummies appear human; mirrors and windows often become doorways into a world behind, and beyond, the surface of the print. Such innuendoes frequently echo subconscious fears; an impression made all the more bizarre by our apparently irrational reading of the ubiquitous and 'ordinary' photograph.

The uneasy feeling that 'something is about to happen' is often evoked through photographs because the process abstracts and freezes a moment in a continuum that we cannot evade. It takes you out of the actual world and places you into the possibly more real world of your imagination. The eeriness in photographs of forgotten and forsaken places, for example, is a feeling produced mentally; what is physically there is a complex of shapes and grey tones. However, the ambiguity of photography makes suggestion into apparent fact and the

'In this world of visual hyperbole, situations are not what they seem to be. Ordinary objects can become anthropomorphized, and the human body can turn into a landscape.'

Facing Page Wideangle lenses are frequently used to produce exaggeratedly surreal pictures. One photographer who did this most successfully was **BILL BRANDT**. He used an old police camera with a very small fixed aperture to produce this almost insect's-eye view of the world. Parts of the body can become strange landscapes whose size in the photographs inverts our normal perception of them in real life.

surrealist eagerly exploits this. The medium can appear to convey reality and unreality at one and the same time.

Of course, this approach lends itself to overt symbolism and to the obvious metaphoric interpretations of images. But even the most practical of photographers finds this area of photography useful – though most rationalists consider surrealistic photography to be no more than the clever production of visual puns. A great deal of surreal humour can be found in the odd and incongruous. The strange juxtaposition of ordinary objects can be extremely funny, especially if it is achieved naturally; but there is nothing deadlier than forced humour.

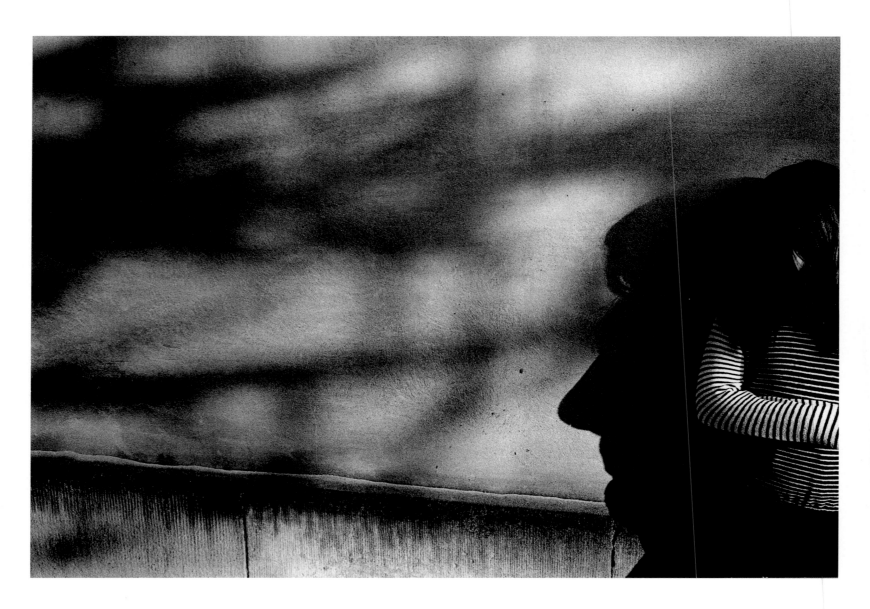

Right Surreal humour can be found in the most unlikely and ordinary situations. How on earth did that telephone kiosk get placed among a forest of ferns? Only the photographer knows the answer. But these situations do exist, and their absurdity is accentuated by the camera's ability to abstract and the photographer's use of vantage point to create, in this instance, an intriguing puzzle for the viewer. **PAUL HILL**

Facing Page Light – the photographer's constant inspiration – can do strange things. The shadow cast by the girl's body here forms a man's head, which appears to dominate her. Photographers constantly stumble over the happy accident, but it is the purpose to which you put that piece of luck that is important. **PAUL HILL**

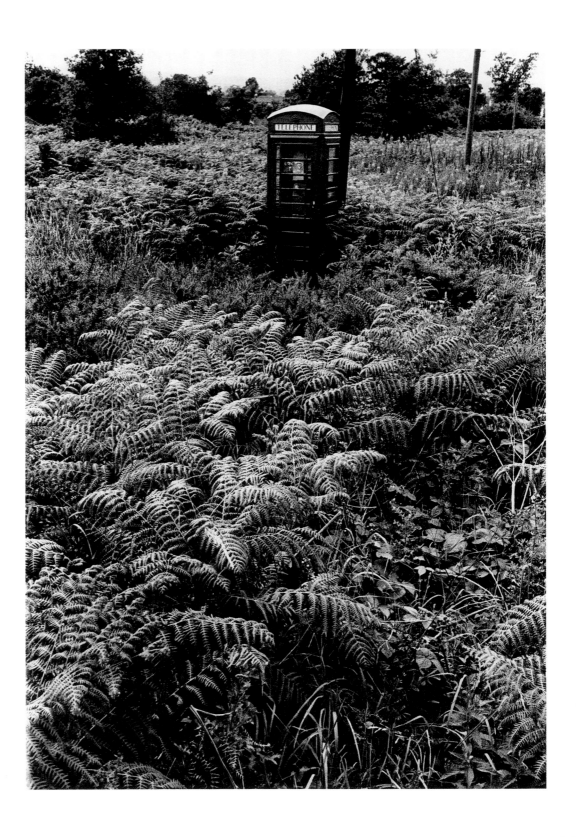

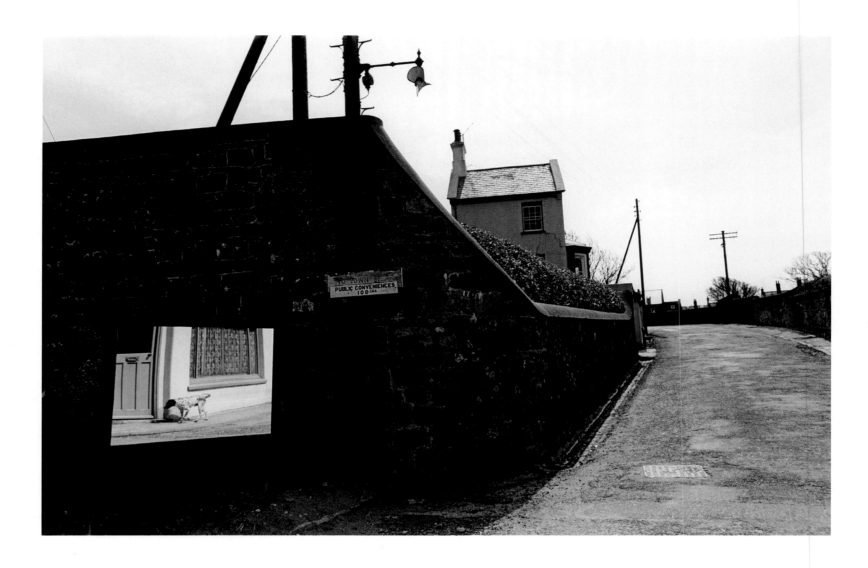

Above The strange unreality that emanates from photographs of mirrors and windows is a thing that particularly fascinated **RAYMOND MOORE**. In this picture, the dog appears to be framed by a window in the wall. The sunny world that exists through that window (it is in fact a mirror used to help motorists) is so different from the shadowy one on this side of that implacable wall.

Below Although there seems to be a great deal happening in this picture, the lack of 'concrete' information makes it most ambiguous. The air of mystery is heightened by the opening (is it a door or a window?) onto the sky. Or maybe it is a painting of the sky and the building is an art gallery? The photograph alone can never give the answer, but that does not matter. The photograph has become the event – and a fascinating and enigmatic one at that. **BRIAN GRIFFIN**

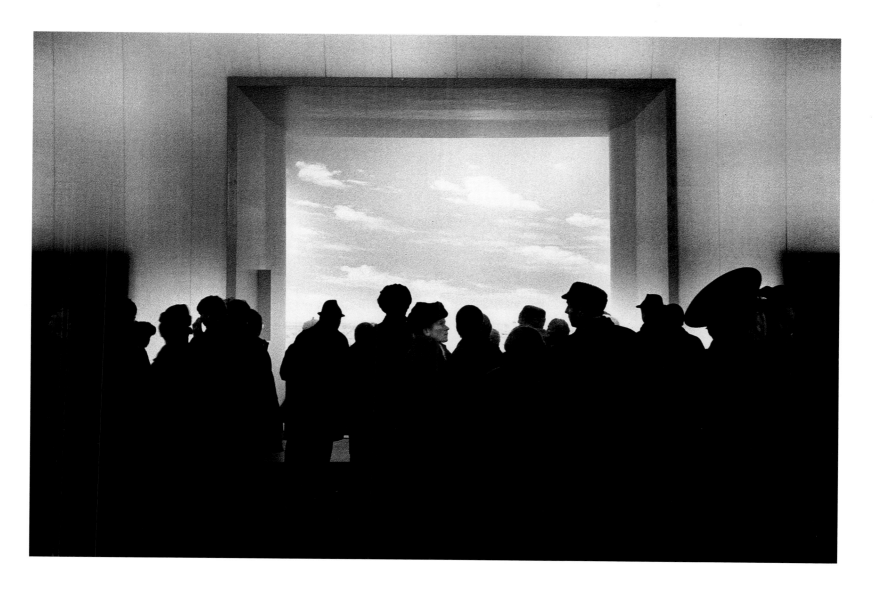

Topographics

The plastic and chrome of city centres, the overhead wires and telegraph poles of the asphalt trail, and the shaved lawns and parked cars of suburbia may seem pretty boring subjects, but in recent years this has been the food that has nourished the vision of a great many photographers. The seemingly straight, visually undramatic, even casual view, however, more often than not contains a great deal of complex information that at first

'The seemingly straight, visually undramatic, even casual view, however, more often than not contains a great deal of complex information that at first sight appears mundane and banal.'

sight appears mundane and banal. The images appear to lack strong formal qualities, and obviously eschew any taint of romantic pictorialism. But the wealth of detail and information bears careful examination and can have an engaging quality that is anything but boring. These minimal 'topographical' pictures seem, on the surface, to be unexciting and featureless, almost clinical. A perfect metaphor for the time out of which they come? Or is this apparently 'dead-pan' approach an attempt to move away from modernist formalism, in order to make the content of a picture more obvious? It can certainly subvert our usual attachment to the visual 'form' or induced mood of a picture. A comparison could be made to a similar movement in architecture that drew attention to the utilities on the outside of the buildings. The structure becomes defined by the elements that are normally 'covered up' for traditional aesthetic reasons.

If we agree that photography beautifies most things anyway, we inevitably end up with recognizably decorative objects, however challenging they may be for some people. This may partially explain why people buy photographs to put on their walls, and why photographers are finding patrons and avid collectors of their work. Having said that, a great many people are now rather suspicious and cynical about photographers calling themselves artists. Is the democratic potential of the medium stunted by its involvement with the art world?

Facing Page This mundane section of gloomy landscape can appear uninteresting – even boring – on first inspection, but the information it contains may merit further examination. The 'extraordinary' usually resides within the 'ordinary', but the search may not be easy. First-glance 'impact' can be very transitory. If you want a photograph to last, it may not be a good thing for all its secrets (like the large stones on the dark bank – what do they mean?) to be revealed too quickly. The stones are, in fact, an improvised arrow directing ramblers on the Pennine Way, a famous long-distance walk in England.
PAUL HILL

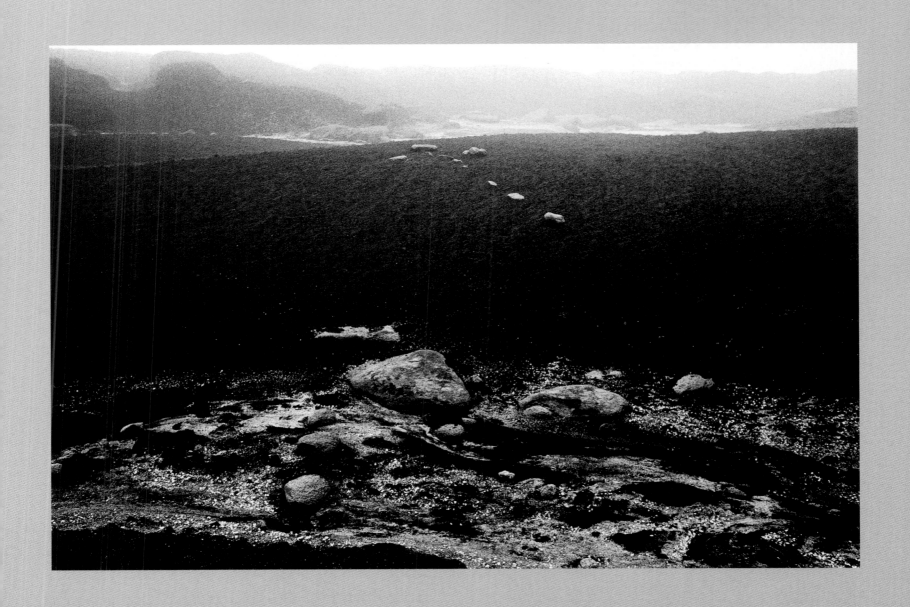

Below Prosaic subject matter like modern housing developments can appear pretty banal, but not for the 'new topographers' of the late twentieth century. Their approach seems as bland as much of the subject matter, but it is a very precise one. This cool, almost clinical style was an attempt to move away from the formal abstraction and fast-shooting street photography of the time, to a classic mode, reminiscent of the nineteenth-century topographical photographers. **LEWIS BALTZ**

Facing Page The empty landscape and a minimally detailed photograph of it can have an almost hypnotic effect. This may be because the eye searches for some recognizable form to rest upon. But like an outwardly featureless 'lunar' landscape, this picture, taken in Cape Cod (USA), positively celebrates its 'nothingness'. You have to let yourself be sucked into it. Minute examination may reveal something to you, or it may not. It all depends on the attitude of the viewer. **HARRY CALLAHAN**

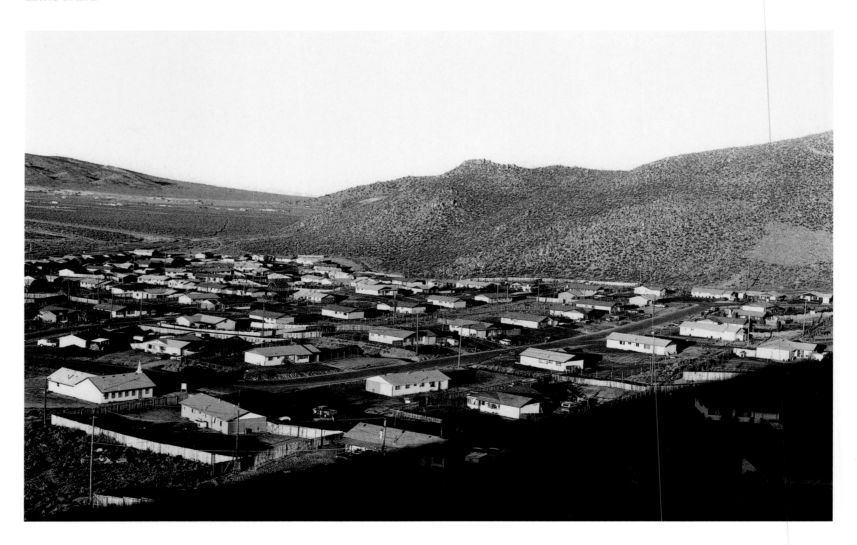

Chapter Nine: **RADICAL CHANGES AND THE IMAGING FUTURE**

> The artist picks up the message of cultural and technological challenge decades before its transforming impact occurs.

Marshall McLuhan
Cultural commentator and academic

Some artists and critics have been cynical and suspicious of photography's 'elevation' as an art form in the latter part of the twentieth century, but many have embraced the medium enthusiastically because they consider it more relevant and contemporary than painting and sculpture. Its prominent position within the visual arts has enabled photographers, as well as those practitioners who are educated as fine artists, to benefit from an extended creative environment. Photography is now an integral part of the contemporary cultural scene, with photographs regarded as fascinating artefacts to be analysed and pondered over. It is also a vital part of media, anthropological and art-history studies. During this period it has attracted academics, philosophers, writers, historians and theoreticians who realize that photographic practice was a conspicuously neglected cultural phenomenon in their intellectual worlds.

Of course, the cynics on the 'art' side of the fence would argue that too much theorizing leads to over-verbalization, and as a consequence virtually negates the use of photography altogether. If every image needs to be dissected and discussed at great length, why bother to take it in the first place? Do you need a post-mortem to enhance your enjoyment of Beethoven or Lennon and McCartney unless you

Above One of the things that conceptualists attempted was to eschew what they thought was aesthetic mumbo-jumbo. The fanciful language of 'expressionism' was too imprecise. There is, however, a wry comment on the vogue for language-centred art in this ironic self-portrait.
KEITH ARNATT

CADER IDRIS

A 21 DAY 604 MILE COAST TO COAST ROAD WALKING JOURNEY
FROM SOUTH WALES TO NORTH EAST ENGLAND BY WAY OF SEVEN HILL TOPS LATE SUMMER 1987
BRECON BEACONS CADER IDRIS BLEAKLOW HEAD CLEVELAND HILLS YORKSHIRE DALES HELVELLYN CHEVIOT HILLS

are a musicologist? But one supposes that even the most dedicated cultural theoretician would not wish to stem the flow of contemporary photographic production despite the millions of photographs that already exist in the world to be examined.

The theoretical approach to photography seems to have two branches: one that concerns itself with the visual nature and process of the medium, and one that seeks to analyse the sociopolitical relevance in/of photographs. This is an over-simplified breakdown, but it may, at least, be a starting point. Although both approaches can be categorized as conceptual (i.e. concerned primarily with ideas) the roots are different. However, there is a great deal of cross-fertilization. The first movement comes out of art practice, but can be said to be a reaction against art institutions and aestheticism, and the second emerged from the world of anti-capitalist politics, but instead of the 'objective' documentary mode it used photography polemically.

Facing Page The purity of the natural landscape and the clarity of simple language are two things that **HAMISH FULTON** conveys in his work. But the most important thing to him is being in, and walking through, the landscape. The photograph plus the text helps him record and represent the wonder of that experience. The activity has a directness and simplicity that is not always present in conceptual art, which most often appeals more to the intellect than the spirit.

Conceptual Art

Conceptualists emerged from art practice, but rebelled against the influence of traditional art historians and the philosophy that said that art was only to do with certain forms of aestheticism. This was, of course, similar to theories and activities of the Dada 'anti-art' movement, which began during the First World War. Many conceptual artists today work outside the confines of the studio, creating large structures often unsuitable for art institutions and conventional tastes, rearranging nature or conducting performances. These 'events' are often temporary and the only way they are communicated is by recording them via the camera. The representation through photography was originally thought to be of secondary importance to the 'act', but in recent years artists have been attracted to the photographic print as the primary object.

The medium is popular with conceptualists because photography is, on the surface, descriptive and unmysterious – everyone can recognize what is going on. It is also a relatively new discipline without all the arcane trappings of painting. The photographic approach seems factual rather than intuitive and this lends credence to the theoretical, logical and systematic ethos of the new art. This also ties in with an increasing interest among artists in science, new technologies, information theory, semiotics and so on. The camera is a machine with limitations and controls that affect things like exposure and focusing, and is, therefore, a respectable phenomenon to explore. This apparently naive attitude angers 'old guard' photographers, who have been known to refer sarcastically to the

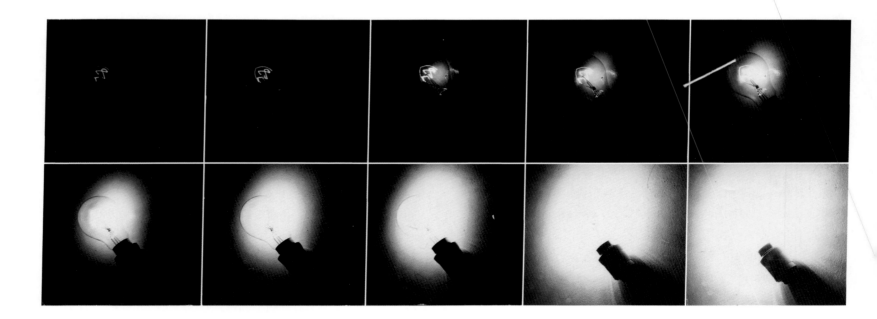

Above The camera is a machine and many conceptual artists saw it's apparent mechanistic limitations and 'ordinariness' as a creative challenge. No one rose to this challenge more than British artist, **JOHN HILLIARD**. Here, in his piece *Light Source*, he has made a series of photographs that clearly demonstrate his fascination with the mechanics of the medium. It shows how the image of an electric light bulb gradually changes with each different exposure available to his camera.

conceptualists' approach as 'Let's pretend'. But the initial resistance of art teachers towards photography might be because their colleges may have fostered among their students a dependence on an art market that is only interested in 'one-offs' and limited editions. Photography can seem to offer an alternative if you do not want to play the art gallery 'game', or are suspicious of art dealers' aims.

Democratic Dissemination

Nowadays, you can put photographs in books that can be made easily available to the public at reasonable prices, you can explore the potential of the postcard and the poster, or you can fax images or transmit them via the internet. In most cases there will be little loss of conventional photographic print 'quality', but this is not of paramount importance to many contemporary practitioners.

The idea should have quality, not the product. The preciousness of the 'fine' object and the limited-edition strategy is anathema, as it smacks of those bourgeois sentiments that put a monetary/rarity value on everything. Photographic prints can, in theory, be produced ad infinitum, which undermines the 'unique object' marketing strategy. Though it must be said that artists who now use photography still only produce one or two prints from each negative and most often exhibit them conventionally in galleries!

The 'preciousness' of the artist/photographer as a special person reflecting, but somehow apart from, the real world, is a stereotype as archaic as the French beret-and-smock image. The artist/photographer is part of a 'system' that will always be political in nature, whether he or she likes it or not. The art that is in galleries – which probably only reaches a privileged few – is not the only art available. Most of us are more directly affected by the visual material in newspapers, magazines, television, advertisements and posters than we are by what is hung on gallery and museum walls.

In photography it is very difficult for the practitioner to avoid coming into close contact with the subject. This provides an ideal opportunity to experience at first hand what is happening in the world and eventually to reflect it through the photographic work. Many people find art's continuing obsession with itself – art for art's sake – disturbing and socially inappropriate. They feel that art should concern itself more with political reality and less with introspection or being successful in the 'star' system so beloved by the dealers and the media.

'Our sense of "reality" and existence is produced by a combination of symbols and images that form a language.'

Signs and Symbols

The influence of cultural studies from the 1970s onwards appreciably affected the practice of photography. Many practitioners and academics within the arts sought to create alternative attitudes and 'histories' to those that implied a linear progression of 'masters' (nearly always male) passing the flame on to younger aspirants. They questioned the traditional pantheistic view of art and photographic history, as they were more interested in investigating meaning and context from a wider cultural perspective.

Semiology helped in this quest. A semiologist not only identifies the possible significance of the objects in photographs, but also tries to analyse why the photographer 'arranged' them that way. Some objects have particular symbolic significance individually, but when combined with other objects in a photograph may have a different overall significance. Our sense of 'reality' and existence is produced by a combination of symbols and images that form a language.

The context in which photographs are used is critical as it can affect our interpretation of them. A great many photographs produced for a mass audience, via newspapers and magazines, are quite often put on gallery walls with little explanation or evidence of the overall form in which they were originally seen. We are now so familiar with the insensitive juxtaposition in magazines of images showing starving people and images of models in glamorous and expensive clothes that they seem to have become stereotypes inhabiting the same

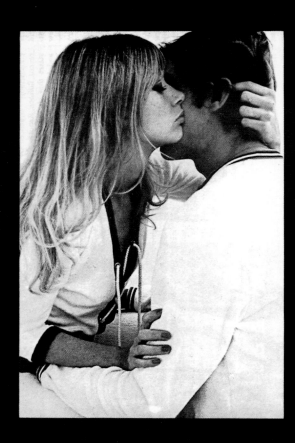

What does
possession
mean to you?

7% of our population
own 84% of our wealth

The Economist, 15 January, 1966

Left Advertisements and posters affect us more than what hangs in art galleries. **VICTOR BURGIN** used posters (and photographic prints that look like posters) to turn the language of advertising back on itself. He believed that we were being sold dishonest dreams by media manipulation, for 'the photograph is a sign, or more correctly a complex of signs, used to communicate a message'. His 'message' is that we cannot afford to be apolitical and ignore what is happening around us in society.

Above This pastiche of a glamour-photography session highlights the way these types of pictures are often read. The woman is portrayed stereotypically as being sexually available. Our blind acceptance of this cliché ignores the political implications of this kind of photography with the woman becoming depersonalized and 'de-classed'. **JO SPENCE**

consumerist world. Poignant and emotionally charged images that are normally seen promoting the work of caring charities have appeared in advertisements to sell manufacturers' goods from fashionwear to cars. Photography, in instances like these, is obviously being used to provoke a debate over taste and to attract media attention, but it does highlight how important context is.

Photography as Propaganda

How can photographs that only represent the surface reality of things change anything in society? Should photography be used for political ends anyway? Large numbers of photographers throughout the world would give an emphatic 'yes' to that last question.

The rise of feminism is an interesting example. Any shop selling magazines will provide you with all the photographic evidence you need of the sexual exploitation of women. This provides a dilemma, however, for those photographers genuinely interested in the female nude as a legitimate subject for their art. How do you get over the hurdle of perpetuating the stereotype of women as sexual objects? This question would almost never have been considered before feminists drew attention to it, with graphic evidence from magazines and advertisements to back up their arguments. Feminist photographers often inverted these clichés to attack those they saw as their exploiters.

It is probably invidious to differentiate between the definitions of promotion and propaganda; both words imply 'selling'. Photographs produced for charities that help the disadvantaged can at times miss the target and seem patronizing or stereotypical. Pictures that set out to shock us into making a financial contribution can just as easily have the opposite effect if we cannot bear to look, or alternatively feel the problem is only solvable through governmental agencies.

Ideological manipulation – often for the highest of motives – is a fact of life that we are obviously aware of when the 'message' is overt; but it is frequently applied on a subliminal level. If you photograph a person staring straight ahead, from slightly below, pointing the camera upwards, you can imbue that individual – whether peasant or plutocrat – with convincing nobility. A similar approach was used by the Nazis in Germany to imply the superiority of the products of racial purity in their photographs of the sunlit faces of young, blond men and women. This effect works because subconsciously we are conditioned to look up to people who are supposed to be 'better' than us; those, for instance, who sit above us on platforms in halls and classrooms, or who are immortalized by imperious, literally larger-than-life statues in city squares.

The media can be a potent force for changing attitudes and influencing opinion in its mission to inform and pursue 'the truth'. But the public have grown suspicious of the aims and objectives of the press and broadcasters. Circulation figures and ratings compromise even the most ardent of ideological journalists. But a sensation-seeking and exposé-conscious media is probably preferable to the controlled, bland sort that exists in many

Above The subtle use of camera angle subconsciously affects our reading of photographs of people. The low angle can increase the nobility and/or larger-than-life character of the subject, especially if they have a large house in the background and an aristocratic bearing. Public figures are very image-conscious, so they will always be photographed, if they can, in ways that do not erode the impression that they are different, special – or in charge! **PAUL HILL**

countries where governments always keep it 'on message'. But it should be remembered that the 'free press' also gives journalists and proprietors the freedom to distort and corrupt in order to garner power, money and influence.

Being visually literate can help us understand the welter of messages and propaganda bombarding us constantly. If you really appreciate the significance and meaning of photographs more clearly, you can use this knowledge, not only as a consumer, but as a maker too.

Photography and Postmodernism

Since its inception, photography has always been influenced by, or in the vanguard of, current art movements. The modernist movement, with its initial radical advocacy of the machine aesthetic and dismissal of handcrafted, cliché-ridden pictorialism, dominated most of the photography of the twentieth century. Originality and the uniqueness of the 'made' artefact were still,

Left Television and films produce celebrities, but they seem to be immortalized by still photography if the contents of historical anthologies, museum collections, institutional archives and bedroom walls are anything to go by. Although he was a talented journalist and writer, Malcolm Muggeridge will be remembered as an often-controversial TV pundit whose ghostly alter ego on the giant video screen behind appears to look down on him in bemusement. **PAUL HILL**

however, integral parts of the value systems in art. Although photography overturned those notions and made the difference between the original and the copy virtually meaningless, there has been a reluctance on the part of most photographers to abandon 'quality' (based on personal vision and innovative and incisive production techniques), even if soft-focus, painterly approaches had been largely discarded. Modernists may have thought of themselves as revolutionaries and outside arcane traditions by making the 'new' and the manmade respectable subjects for art, but they also wanted to be the dominant force and inevitably became the new establishment in art *and* photography.

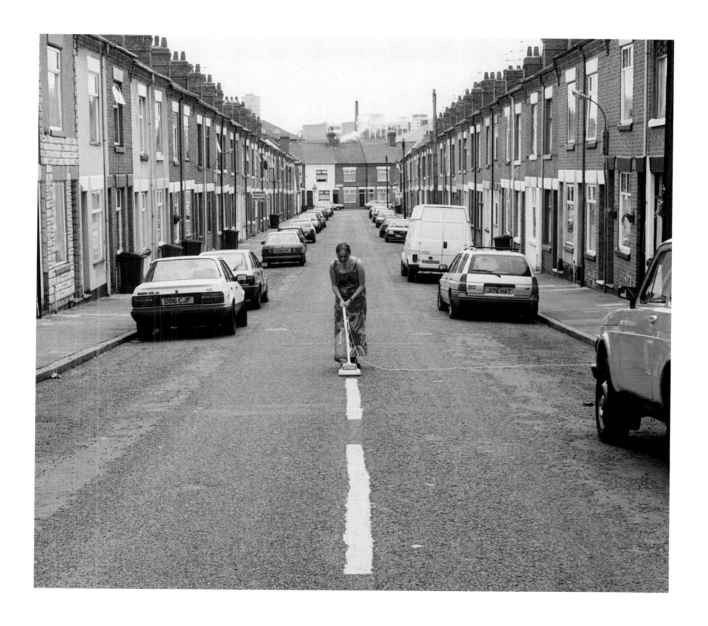

Left Photography has been a major force in the contemporary art world previously dominated by painters and sculptors. Artists use the medium because it is integral to our everyday lives, as well as to record the installations, performances and tableaux that are their created artworks. This picture inverts the 'normal' role of the woman as housewife by dressing her in an evening gown and taking her out of the home to do the vacuuming. This absurdist piece has an overt feminist edge to it, but it also shows pathos as well as humour.
JOSIE BOURNE

Postmodernism wanted to take things further by culturally undermining the modernist aesthetic approaches to making art and creating a critical environment where qualitative judgements were almost impossible with all types of visual material given equal status. The convention of separating 'good' from 'bad' was seen as irrelevant. Historical paintings were montaged with images from popular culture; installations, performances and tableaux were created purely for the camera; everyday mass-produced objects and things kitsch became imbued with exaggerated significance in this postmodern world. Photographs also became regarded as signs, simulacra and signifiers by its commentators rather than crafted images of personal self-expression. Postmodernism reflects a visual environment in a constant state of flux, dominated to a large extent by pastiche and trivia, but also by the photograph. Photography serves this world well, as it is accessible, accurate and authoritative without being elitist.

Electronic Imaging

The computer and the digital camera have revolutionized photography and brought in their wake many exciting imaging possibilities. But what difference has it really made to single-perspective image making?

One of the most intriguing issues concerning electronic imaging, apart from the ease with which images can be transmitted almost instantaneously to outlets anywhere in the world, is the status of the 'electronic photograph'. In reality, it is not a

Above In this montage – a comment on contraception – the condom 'petals' are made by electronically scanning in one photograph and cloning it to produce a multiple. The piece was made so that it could be accessed easily and, if required, printed out, framed and hung on a gallery wall or used for health education purposes. **JOSIE BOURNE**

photograph in the sense of a tangible photographic print or transparency, but an image that exists as electronic data. Computer-held data can also be used to create images that simulate photographs without a camera. While it is true that these electronic images trade on the authority that photographs have, and are usually based on other photographs, they are nonetheless a deception. If it is its 'believability' that gives the photograph its status in society ('I was there and this is what I saw'), are computer-generated images no more than sophisticated fakes?

This post-photography probably has more in common with computer graphics and multimedia practice, where first-hand involvement with the real world presents visual problems rather than the sort of opportunities relished by most photographers.

'While it is true that these electronic images trade on the authority that photographs have, and are usually based on other photographs, they are nonetheless a deception.'

DIGITAL PHOTOGRAPHY

On the surface it appears that photographs made electronically and those made chemically are virtually the same because the digital systems are made to imitate 'real' photographs by replacing photographic emulsion, embedded with light-sensitive silver halides, with a numerical grid of small picture elements (pixels). High-quality prints (i.e. those with a full tonal range and minimum 'grain') can be produced by either route and only a magnifier can reveal the process used. You can even simulate 'burning' and 'dodging' by using the appropriate computer software, then produce an ink-jet print on almost any paper surface you like. Personal taste and circumstances inevitably affect which method you use to make pictures, but the technology should always be in the service of your ideas and not the other way round.

Conclusion

Photographers almost always need to foreground their physical presence, as witness or artist, in the real world. They use photography – to record and create, and to celebrate and criticize – because the medium has unique qualities. The authenticity of our way of viewing subject matter optically, and the reconfiguration via the camera into a still image, is pivotal to the makers and consumers of photographs.

New, electronic imaging technologies offer us an exciting extra palette of possibilities as camera users. They will, of course become 'old' technologies in time – and rediscovered, perhaps, like non-silver printing processes were in the 1970s – but at the moment they are responsible for much debate and discussion, including important questions concerning truth and integrity. This is always the case when a new epoch arrives. The one thing you can be certain of when considering the future, as well as the past, is that change is always with us. The period of history during which photographs have been around has seen great social, economical and spiritual changes. Photography has been found to be the most effective way of chronicling that period by reflecting the prosaic and the dramatic, the mysterious and the ordinary – and the joys and sorrows that affect us all.

You have almost certainly found out by now that photography can be a very difficult and humbling medium that frequently raises more questions than it answers. Always remember, though, that it has to be enjoyed if it is to be illuminating and rewarding for you or your future audiences.

ABOUT THE AUTHOR

Photo: Mike Simmons

In the 1970s, Paul Hill chose to leave a successful career in photojournalism to concentrate on his own photography and to work in photographic education. His first post was at Nottingham Trent Polytechnic, where he was later appointed head of the forerunner to all current student-centred higher education courses in creative photography. Another notable achievement during this period was to open, with his wife, Angela, The Photographers' Place, which was the UK's first residential photography workshop. Since 1995, he has been Professor of Photography at De Montfort University in Leicester, UK, and has continued to lecture and hold photography workshops in Europe and the US.

A major influence on contemporary British photography, Paul was awarded a Fellowship of the Royal Photographic Society in 1990 and an MBE for his services to the medium in 1994. He has exhibited regularly since 1970, and collections of his work are held at galleries and museums worldwide, including: the Victoria and Albert Museum and the National Art Collection in London, the Museum of Fine Arts in Houston, Cleveland Museum of Art in Ohio, the Bibliothèque Nationale de France in Paris, the Australian National Gallery in Canberra, and the Foundation for Photography in Tokyo.

He is the author of two further titles: *White Peak, Dark Peak* and *Dialogue with Photography* (with Thomas Cooper).

INDEX

INDEX OF PHOTOGRAPHERS